CW00551117

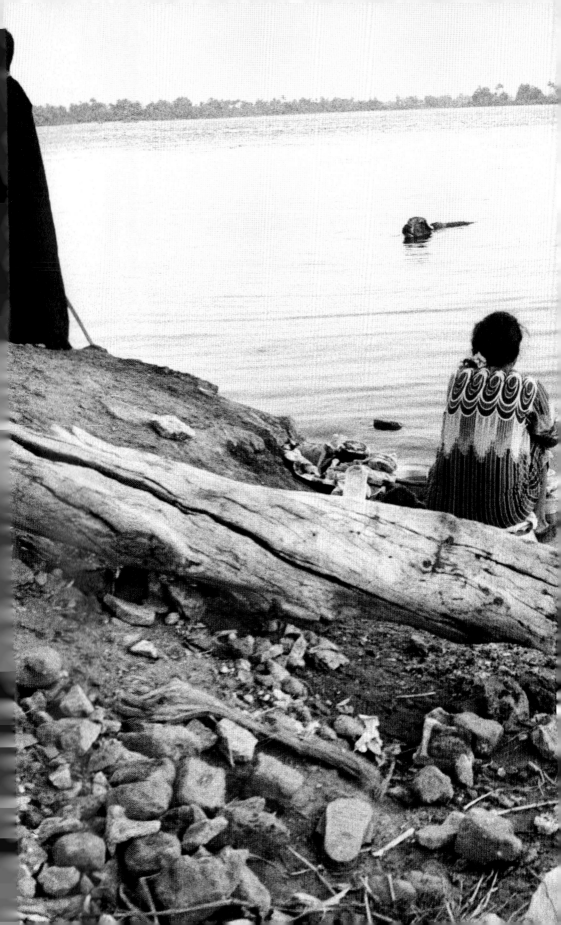

rifugi

CHRISTIANS OF THE MI

Schilt Publishing

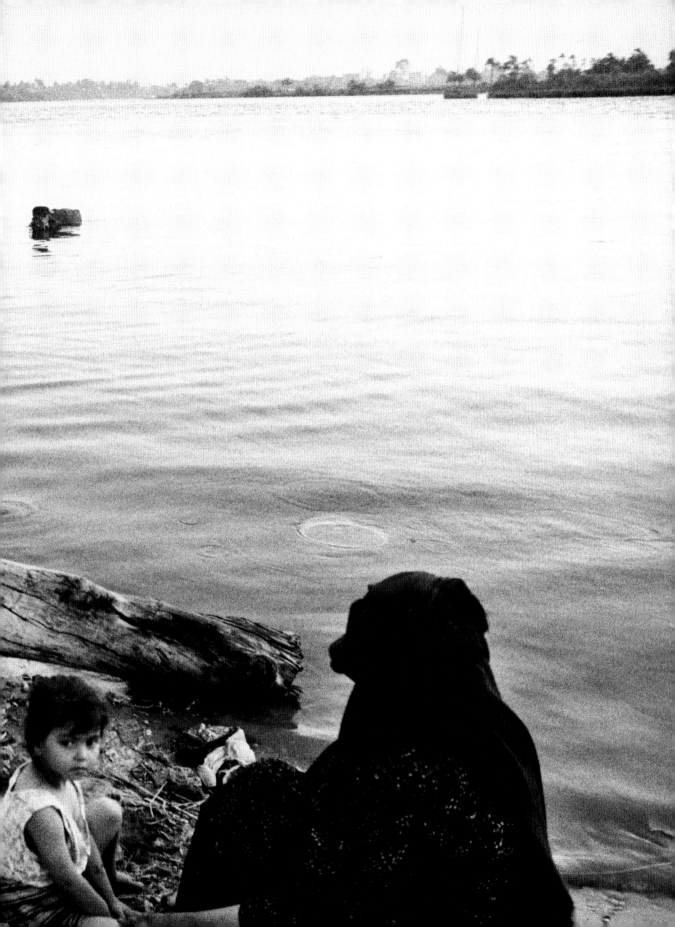

This book is dedicated to Ivan Bonfanti and Paolo Vittone

introduction

At first we kept count of the churches, monasteries and houses that hosted us, then we lost it along the way. What is left is *Rifugio*, the story of an intimate and deep journey. Two years, seven months and ten days have passed since the dawn of June 21st 2011, the day we left Trieste on our bus. We went to Iran, crossing Serbia, Bulgaria and Turkey. It was a slow journey – as slow as our approach to this adventure.

During New Year's evening mass 2011, an explosion destroyed the Saints Church in Alexandria. Twenty-one Christians died. The story appeared in Western newspapers and on television, but after a few days the media's attention faded. We felt the need to know more. We wanted to get to know these millennial communities and give witness to their experience after the media exit. So we left, to discover stories, families and villages in their everyday lives. We were looking for the heirs of the evangelists and the first pilgrims. In some cases have retraced and followed their steps, crossing the borderlands that divided Paganism from Christianity. Maku in Iran, Deir Abu Hennis in Egypt, and the Turkish Antiochia are tiny points on the atlas, but they are the vestiges of a journey that has reached us after two millennia. We never left the house, we only explored other rooms.

We arrived at Qara Kilise church, Iran, thanks to a book we found by chance a few weeks before departure, in Rome, in a library that is now gone. We read about the Armenian pilgrimage to a particular church lost in the mountains between Iran, Turkey and Azerbaijan. We left at night, aboard a bus loaded with people and luggage. On the lawn in front of the church they gave us a tent which was stolen by a storm soon after. So they welcomed us in a room inside the monastery, but the regime's local officials didn't want foreigners and Iranians sharing the same accommodation. So we slept in the church that dated back to 60 AD. We laid out some blankets and moved a bench to the side to avoid disturbing the devotees who took turns all night to pray. We spent three nights like this. It was possibly the most truthful beginning for our trip. A few

months later we travelled across Egypt from north to south, seeing the Nile flowing in the opposite direction. We left a village where you walk barefoot and drink dawn-fresh goat milk before getting on a slow train to the border of black Africa. We saw the Tigris many times, incipient in Turkey, welcoming at the border of Syrian and Iraqi Kurdistan, majestic where it joins the Euphrates in Basra, southern Iraq. Basra is the non-Iranian city that looks the most Iranian. The public behaviour code is rigid, and guarded as strictly as in the streets of Tehran. We left the town, which was teeming with meetings and tension after a few days. We moved to Sulaymaniyah, northern Iraq, and we were received very differently: fish dinner with white wine. We also experienced the precious diversity of the Middle East in Beirut, where we have lived for the past two and a half years. We fell into a reality of four and a half million people sharing a country as small as it is complex. Leila – whom we rented the house from – is a Sunni Muslim, while her husband is an Orthodox Christian. They married in a civil ceremony in Cyprus because in Lebanon mixed marriages are forbidden. Leila and her husband have never had problems with families, work or friends. But Beirut is also a city divided into districts, where each community feels secure in its fort. It's a city that after fifteen years of civil war is still dealing with car bombs. We made the daily life of the Lebanese our own, and *Rifugio* would not have been born if we had not shared this reality.

Month after month, the places we travelled to progressively changed. We came across the Muslim Brotherhood in Egypt, in Iraq with no U.S. marines, in the Syria of Bashar al-Asad and Isil. The story unfolded before our eyes, right in front of us while we were looking for normality. Wars, old and new, made things difficult for us. Once the umpteenth war between Israel and Hamas was over, we entered the Gaza Strip as 'Monk' and 'Sister'. It was the only expedient that the priest of Gaza could devise to induce Hamas to grant us a visa. Because of the war, we waited three years before we could get to Damascus. The heart of what was Greater Syria, a religious and spiritual country, was dripping blood beneath the bombs and fighting. We moved to Syrian Kurdistan, where a Muslim woman had opened the doors of a church for us, showing us the value of co-existence.

The refuge of the Christians in the East is a safe, familiar place. It is the port to which they return when there are a few of them left, where there is no need to speak to

identify each other. It is a safe place, the land they are used to walking. But refuge also means an escape for fear. It is the lair where they hide when everything looks dangerous and hostile. We were greeted in this shelter as friends. For the people we met we were a reporter and a photographer, but we were walking on tiptoe. Linda took photos only when the presence of the camera would not have broken the bond of trust. Her photos go beyond space and time. They are sincere like a family album.

An estimated twelve million Christians live in Egypt, Israel and the Palestinian Territories, Lebanon, Syria, Jordan, Turkey, Iraq and Iran. They are the narrators of this book. They have entrusted to us tragic, romantic, and comic stories. *Rifugio* gave us examples of co-existence and exclusions, of relationships based on people and of ghettoization. We reported the version of the Christians, without concealing any hostile attitude towards Islam and Muslims. We have repeatedly faced sectarian viewpoints but we did not surrender to those who sought to foment a clash of civilisations.

We report everything in the following pages. You, the readers, can become part of our journey through tales and images. We hope we will be able to take you with us on the same bus that left Trieste that morning.

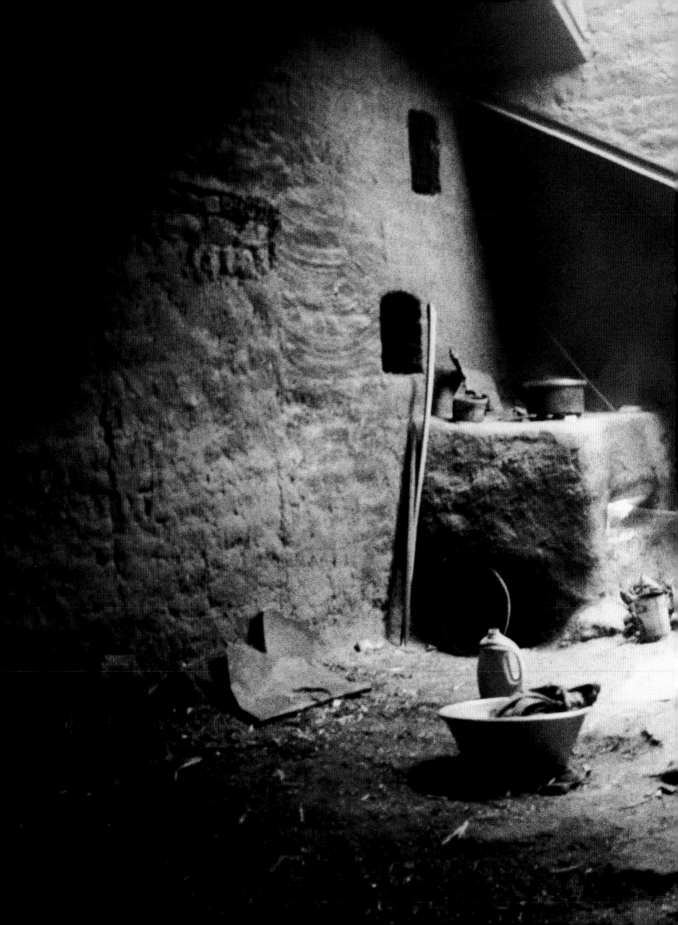

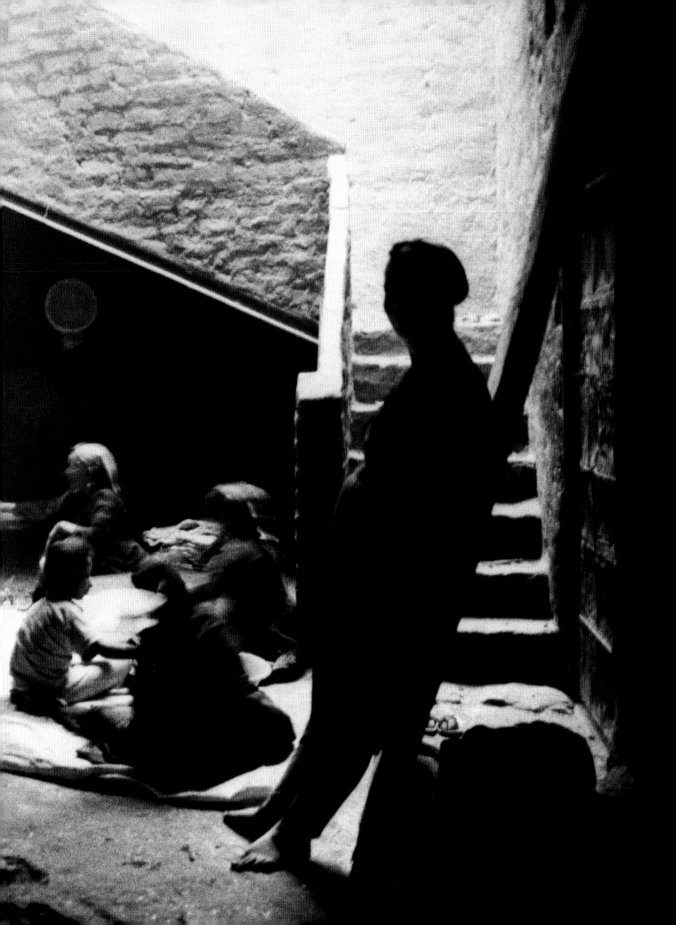

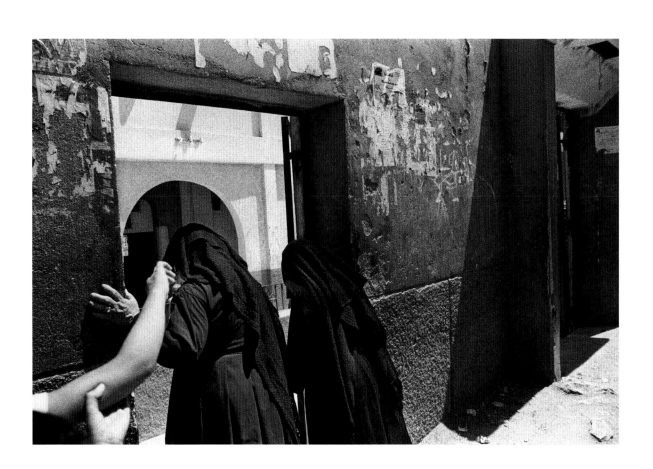

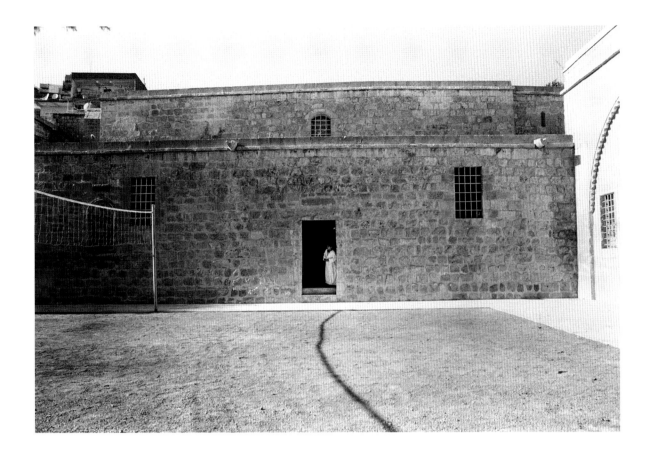

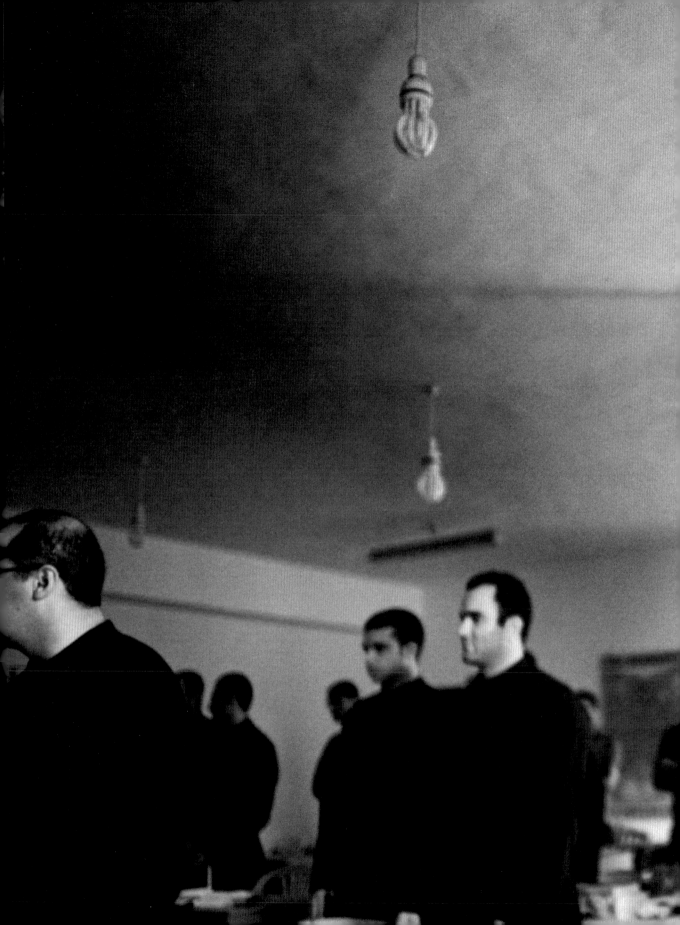

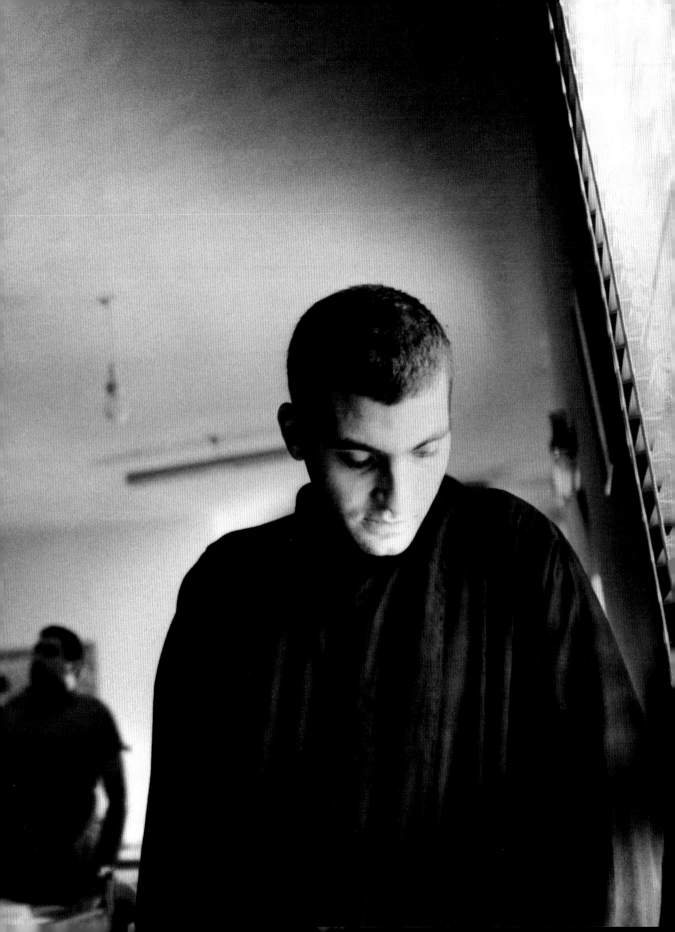

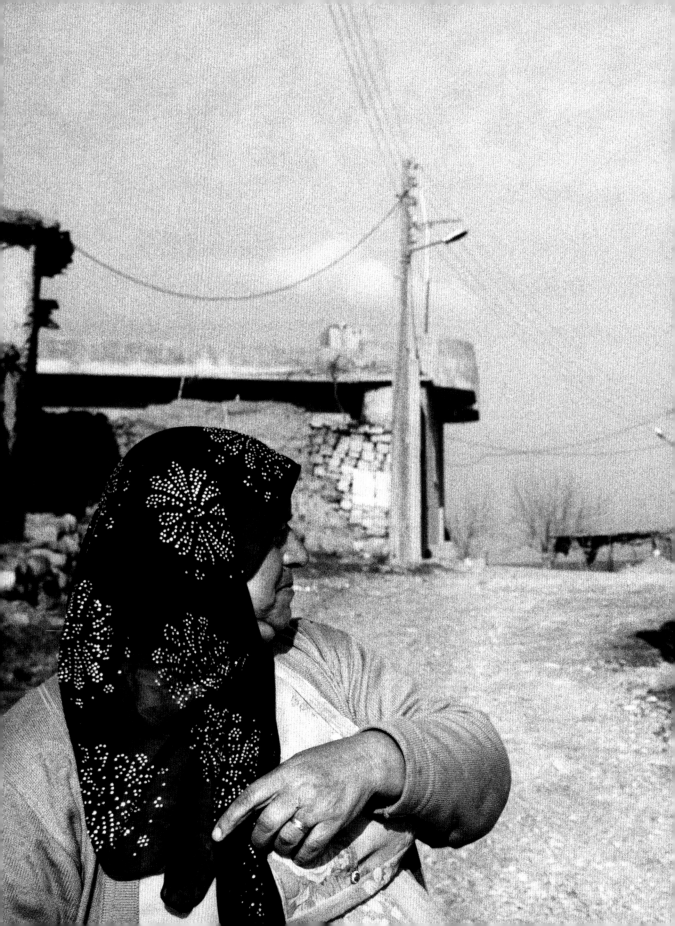

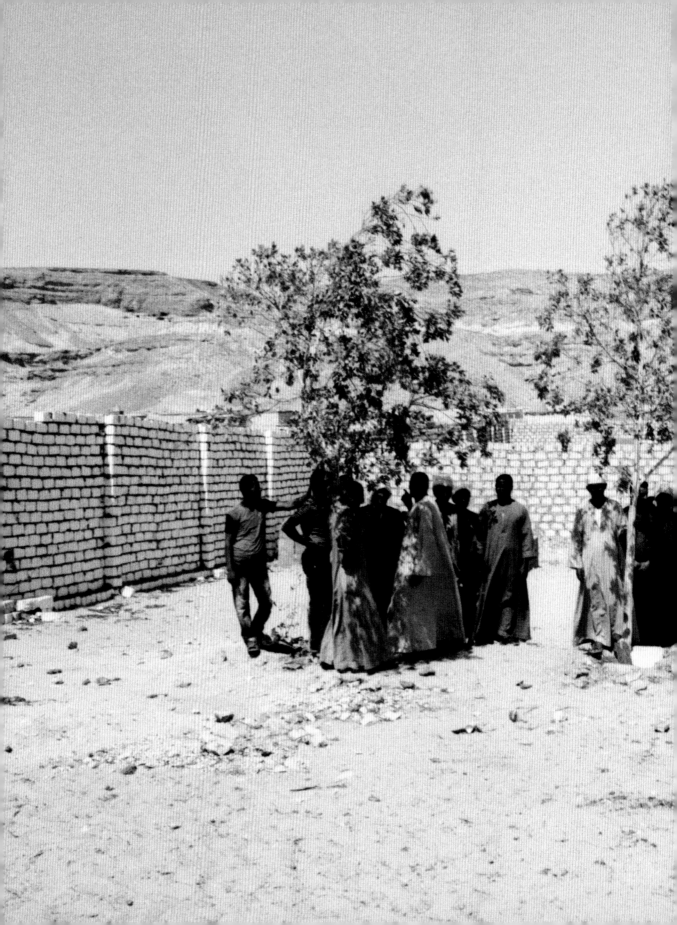

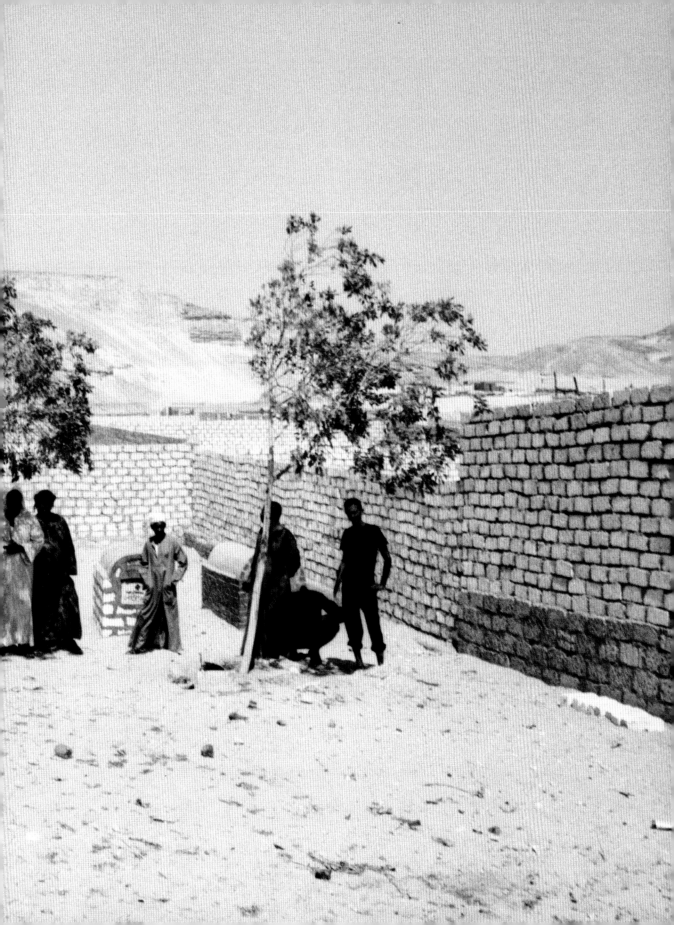

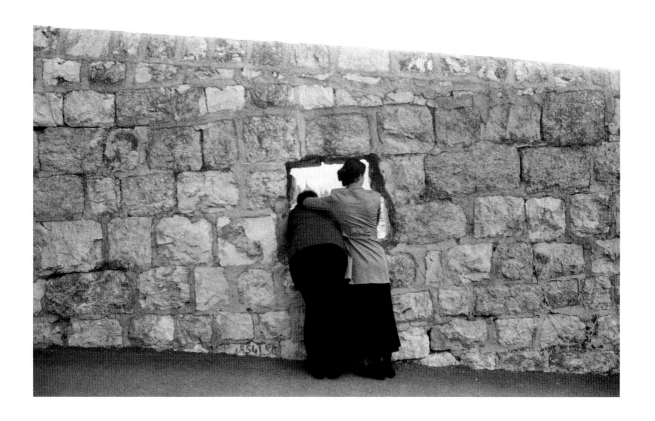

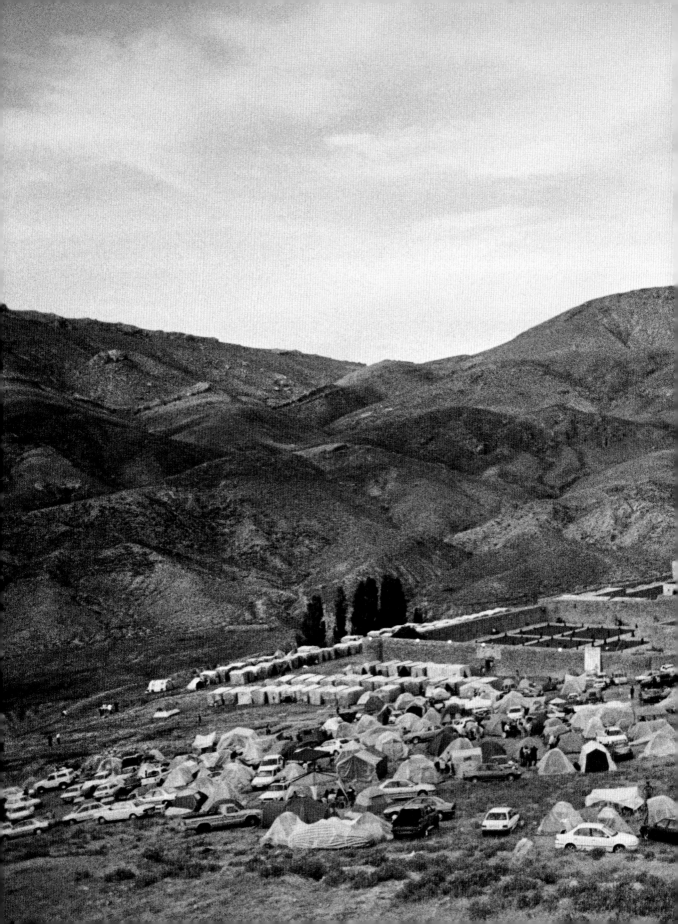

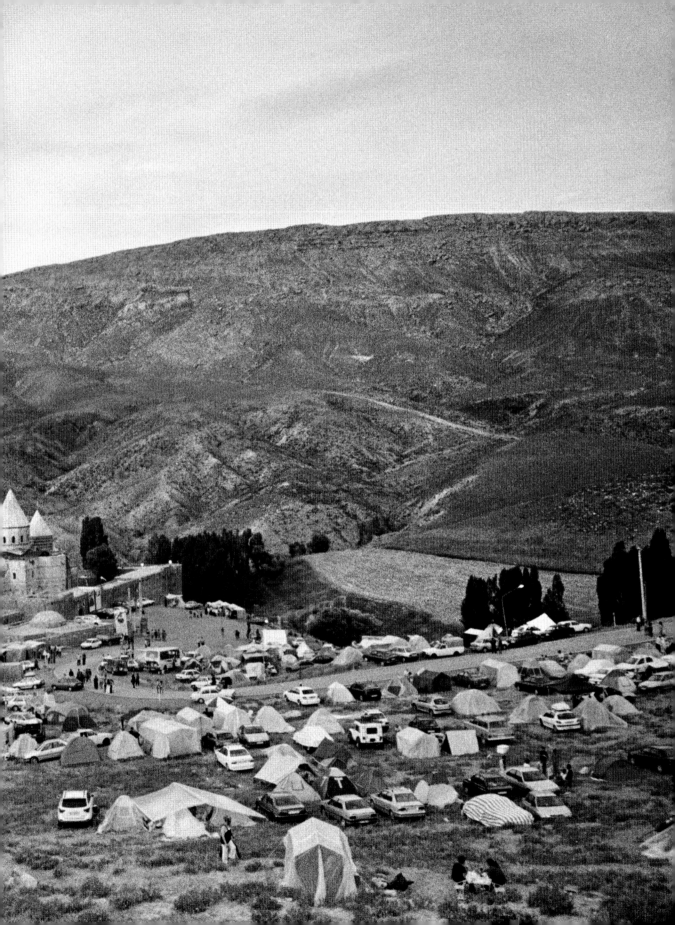

enclave

The antiquity of Christianity lies in the valleys that go from the Iranian slopes of Mount Ararat to Mount Lebanon. A multitude of rituals and songs intertwine, while deserts become the mystical scenario for monasteries, and mountains don't mark borders – they draw paths to smell the sky. Qara Kilise, the black church, has been awaiting its pilgrims for centuries at the eastern tip of Iran. "Welcome, this is Armenia. Are you Christians? We are also Christians, you don't need to worry," say the young people at the door, smiling to us. Built in honour of Saint Thaddeus, a disciple of Jesus, shortly after his martyrdom around 70 AD, Qara Kilise monastery is a force strong enough to overshadow any other human endeavour in the same surroundings. It reveals gorges, mountains, the shelters of nomadic populations and a patrol of soldiers. We get there together with the Armenians from nearby Tabriz. It's mid-July. The lawn begins to fill up with pilgrims. Two giant portraits of the Supreme Guides – Ruhoallah Khomeini and Ali Khamenei – tower over the stone wall surrounding Qara Kilise. These Ayatollahs have alternated as leaders of Iran since 1979. The annual pilgrimage to St. Thaddeus attracts Armenians from all over Iran, Turkey, Armenia and Azerbaijan. "Guys drink alcohol and sing till dawn, girls sunbathe in their bikinis. For us, who feel like strangers in our own house, this pilgrimage is a sort of liberation," says Melik, a young IT technician from Tabriz.

The church door stays always open, to allow church-goers to come and go according to their schedule. Time flows among functions, prayers, walks and group dances.

"Do you know Bobo Vieri?"
Christina is the 22-year-old daughter of one of the pilgrimage organisers. She is here with her family and her boyfriend, with whom she shares the same age, religion and desire to do what most young people want to do all over the world.
"As we are not married, we need to be careful in the city: our families are scared of what other people might think if they saw us together."

"A man usually fears law and God, in Iran these two things coincide," says Father Ratevosian, bishop of Tehran, with a sly smile under his grey beard. "If you ask Christians to explain to you how they live, no one will ever tell the truth, because the regime is everywhere and we always have to put a good word in."

Armenia is their land, but most of them have not been there yet.

But in Qara Kilise, Armenia is ubiquitous, flags seems to pop up everywhere: from under the trees, among the stones, from the back of cars.

This is a closed community, that meets up every year to quantify its members.

"I'm not herding a fold of devotees, but a bunch of nationalists," grumbles Father Ratevosian.

"I'm Armenian and work with Armenians, my wife is Armenian and teaches at an Armenian school, all of our friends are Armenian," says Rafik, a photo reporter for Alik, a newspaper published in Armenian in Tehran. He lives in Vanak, the highly popular area in Tehran among its two thousand Armenian residents. It hosts different churches, and three hectares of freedom in the Ararat centre. In the Ararat, Armenians get married, can go to the swimming pool and to the gym with different timetables for men and women. There is also a football stadium where women are not admitted if there is a match between Christians and Muslims.

"We have nothing in common with the Muslims. They are dirty, we are not. They pray five times a day, we don't. They don't show any interest in culture, we do," criticises Artemise, who lives with an indefinite number of cats on the first floor of Rafik's family five-storey house.

Many of the Armenians in Iran have relatives and friends abroad.

Those who stayed have closed their doors to spy on other people's lives.

"They fought to maintain their identity and language. If they were more open, they would have been in trouble," points out Father Franco, a priest at the Italian Embassy Church for over forty years. "Can we say we are persecuted? No, because we have our spaces. Can we say we are free? No, because we suffer strong discrimination. But, if in 1978 in this country there were eight million Christians out of forty million inhabitants, and today they are sixty thousand out of seventy million, there must be a reason, right?" Armond has travelled in the opposite direction. "They fought to preserve iden-

tity and language. When I was a child, my family escaped to Los Angeles and I became a political refugee. When I grew up, I realised that if you don't have money you can't do anything in the U.S., but live to make money. So at twenty-eight I went back to Tehran, repossessed my old house and opened an Italian restaurant. Iran has its rules, but once you know them you learn how to get by. And if you lead a regular life, you live well."

Minorities need to identify their members, both in their countries of origin and abroad. One of the most popular destinations for Christians leaving Iran is Lebanon, where identity comes even before nationalities and eighteen different denominations compete for the register of four and a half million citizens censused only once in 1932. Lebanon is a straight line on the Mediterranean, constantly interrupted by army checkpoints. Past the city of Tyre and the Litani River, the South becomes a country of its own. Pompous villas appear in striking contrast with banana plantations and villages that were never rebuilt after the war against Israel in 2006. Dozens of barefoot children chase each other under the portraits of Hassan Nasrallah and the martyrs of his Hezbollah, the 'party of God'. "Can you see those mountains over there? Those with antennas? Well, that's Israel spying on us," laughs Elie (33), manager of one of the two pubs in Ain Ebel, a village of 1,500 Christians. A permit from the army is required to get close to the border with Israel, but it is Hezbollah that commands. "They control everything, they have tunnels to reach Israel and underground weapon storage. No one can get close, not even us who live there," explains Elie. "During the war, the Hezbollah were coming to Ain Ebel by motorbike to shoot rocket launchers against Israel. The Tel Aviv army located us and we remained under bombardment. Once my parents stayed locked in the basement for seventeen days. Hezbollah chose Ain Ebel precisely because we are all Christians. It's Easter Sunday and midnight mass is packed. For younger people the night goes on in pubs, and beer accompanies reunions with those who return from afar.
"I also wanted to go to Australia, but the emigration office rejected my application twice," reflects Elie. "In the end I'm happy I decided to stay because here I have my family and the tranquillity I need."

The Christian scene in Lebanon includes twelve different Christian, Catholic and Orthodox denominations. The Lebanese constitution provides that the President of the

Republic is chosen among the Maronites, who form the biggest Christian community. Each denomination has representatives in Parliament, places of worship and enclaves. The majority of the Armenians living in Beirut are in Bourj Hammoud, an area that has more in common with the Armenian capital Yerevan than it does with any other neighbourhood in Beirut. "It's very simple: Muslims exterminated us and we cannot share anything with them," says Rita vehemently as she opens the door of her house in Anjar, an Armenian village in the Bekaa Valley, on the border between Lebanon and Syria. Here the Armenian, the Christian Orthodox, the Catholic and some Protestants live together. It is April 24th, and as in every year, Anjar is preparing to remember the million and a half Christians exterminated in 1914 and 1915 by the Young Turks who headed the Ottoman Empire. The march against Turkey, which has never recognised the massacre as genocide and which has never awarded any economic and political compensations, is now in Beirut. Anjar organises five buses. Vartan 'the historian', a re-tired professor who wrote a book about Anjar, makes the most out of our long journey to bring us back to the past. "In 1914, after resisting the attacks of the Ottomans for forty days, the young people of Musa Dagh, led by a priest, were rescued by a French ship and taken to Port Said, Egypt. In 1923 they moved to Lebanon and at the begin-ning of the Forties they founded Anjar. We are their direct heirs." The story of Musa Dagh, the mountain of Moses on the border between Syria and Turkey, is a milestone for the Armenian identity. That resistance has saved Vakıflı Köyü, the 'first and last' Armenian village across Turkey. "This is the only one left of the eight villages of Musa Dagh. Ten years after the genocide, Atatürk built the Turkish State and promised equal rights for Turks and Armenians. Many did not believe him and left, but we stayed and kept on speaking Armenian in Turkey," states Panos proudly, having spent eighty-one years in green Vakıflı Köyü. The Musa Dagh is a plateau made colourful by orange trees and decorated by isolated houses; there is only one bus, that stops at the square in front of the church and then goes back on the trail that leads to Samandağ, the nearest vil-lage, about four kilometres away. One hundred and fifty Armenians in thirty houses: "This village is likely to die because young people do not want to be here," continues Panos. "They spend their holidays in Vakıflı Köyü." "In Istanbul I lead a completely different life," confesses Noura, a 21-year-old girl. "I come to this village every August as my mother's roots are here, because being Armenian means to respect the community

and its places. We have to come to terms with the past, even though we have a different mentality. For me, marrying a Turkish man wouldn't be a problem, but if I did I would be a great disappointment for my parents."

In Garbage City, the garbage district of Cairo, a dense web of alleys stretches across the road covered by junk that children play with. Cows and women share the same stable, shaking hands and tails to swat away the flies invading their habitat. Garbage City is the home of the zabbalin, or the garbage collectors: "In the Sixties, the first Copt moved over here, at the foot of Mount Muqattan," said one of the priests of the monastery on the mountain. They came from Imbaba, a village near Giza, where they lived in poverty, facing persecution. Father Simon, the head of the monastery, managed to build some houses, then negotiated bathrooms and kitchens with the government. A city was born out of nothing. Father Simon came up with the idea of using garbage to create jobs and transformed this area into the place where you recycle all the waste produced in Cairo. About forty years later, 60,000 Copts are living in Garbage City and the previous 100% poverty rate has been halved. Men start the collection at 2 AM, then go to rest in the houses on the second floor while women and children separate the waste. The zabbalin are proud to live at the foot of the 'mountain that moved', as the Muqattan has been renamed according to the legend. In 939, Caliph Al-Mu'iz challenged Pope Abram to test the passage in the New Testament that says Christians could move mountains with faith. If Pope Abram failed to move the Muqattan, the Caliph would ban Christianity as a false religion. The Muqattan moved, the Copts were saved, and since then the monastery overlooking Garbage City is a destination for pilgrimages.

"Muslims must not come here because wherever they go they create disasters. You Westerners live too far away to know the Qur'an and its followers." This is a popular belief in Deir Abu Hennis, a sleepy village on the shores of the Nile in Northern Egypt, a high-transition zone from the Mediterranean to the first African skies. All 14,000 residents of Deir Abu Hennis are Coptic Christians. A few weeks before the revolution, Mubarak's government tried to change the name of the village and to build a mosque. An uprising broke out. "Mubarak was ousted before he could carry out the project. History repeats itself," says Helal, a deacon and a man of reverence of the community of Deir Abu Hennis. "In 1981, President Sadat imprisoned our Patriarch Pope

Shenouda, but forty days later a fundamentalist killed Sadat. We are optimistic because God protects us and His will will always be done." Deir Abu Hennis is an enclave, independent from time and from the map: "When someone leaves the village he says he has to go to Egypt, as if we were living in another country," laughs Helal. This isolation creates a sense of closure and fear towards the Muslims. But I maintain that we should love everyone." A jellaba – a black long tunic – over his bare feet, grey-bearded Helal is also an archaeologist, husband and father. "In college I was the best in my class. I needed a scholarship to continue but I was never granted it because I came from Deir Abu Hennis. They gave it to another student, a Muslim. It was disappointing but still didn't take me away from Egypt." At Deir Abu Hennis there is a barber, a market run by Joseph "the biker", the small kingdom of teacher Mina who remembers the names of all his students, houses without doors, four churches and a cemetery where it is strongly recommended not to get lost at night. When it gets dark, Deir Abu Hennis is transformed into an open-air campsite, families sleep on the roofs and the stars are the only witnesses of their freedom.

In the middle of the Egyptian desert it's hard to preserve loneliness, which in the Middle East can be due to exclusion or thanks to meditation. One can look for it or just be thrown into it: the perspective changes depending on the place and the community you belong to. In Israel there are about 700 Hebrew-speaking Catholics, converted from Judaism. Jewish society believes Christians are responsible for the Holocaust and so the Hebrew-speaking followers are doomed to a hideaway life. "When I told my parents I had converted, I became the traitor of my ancestors who died in Europe," admits a 33-year-old boy from Haifa. The Hebrew-speaking Christians are ghosts in a land torn by the conflict between Israelis and Palestinians, where religions leave little room for individual paths. The incarnation of loneliness is Father David, South African by birth, of Israeli origins, and Palestinian by adoption. "My parents moved to South Africa because Israel was at war against the Palestinians. I was born in Johannesburg, where my father founded the first Jewish community in South Africa. There I learned Hebrew and I became familiar with our culture," says Father David. Meanwhile I used to read the Bible, went to church and I had already accepted the idea of converting to Christianity and taking vows. I told my parents that I had been asked to wait another

ten years. Shortly afterwards, the fight against apartheid broke out and the situation worsened for us whites. So they sent me back to Jerusalem, where I started my second life." Father David sinks heavily into the seat of his chair in the Vicariate. His blue eyes betray the emotion of the story. "When I arrived in Jerusalem I did not know anyone, until I made friends with a Palestinian boy and his mother practically adopted me. I decided to do what the whites in South Africa refused to do: I learned the language of the other, Arabic. I soon found myself having two families, a Jewish one in South Africa and a Muslim one in Jerusalem, while I was only expecting to convert to Christianity." After the ten years wait he had agreed with his father went by, David was baptised, and three years later he became a Jesuit priest. Now he sounds amused when he remembers that day: "According to the ritual of the ceremony, all guests would have to kneel in the church, but I could be an exception because neither my family nor the Muslim Jew would do that."

The Hebrew-speaking Vicariate is located in the most modern part of Jerusalem but it is white, like the magic of the ancient heart of the city. It is not signposted and no one around knows exactly what's behind that high gate to the street. Jerusalem is busy writing its story, but only a few people know that a small piece of it bears the signature of the Hebrew-speaking Christians.

fear

"In Alexandria only the elderly resist, because they don't have the strength to leave," confesses the host of a restaurant on the waterfront of the second largest city of Egypt. Alexandria cannot remember its past without crying. On the night of December 31st 2010, a bomb attack in the Sidi Bishr area gutted the Saints Church, killing twenty-one people. It has been almost two years. It's a Sunday in mid-August, but the heat has not deterred the faithful waiting in line for the mass. At the entrance, two policemen and a metal detector check handbags and shopping bags full of sweets and candies. "I'll never forget. I have seen hell unleashed in that church," begins the parish photographer. "A loud explosion and the sound of breaking glass. A lot of smoke, a river of blood and people fleeing in panic, stepping on corpses and on the wounded. We kept on finding human remains on the trees for the following three days."

Five thousand Coptic families lived in the district – after that night less than half were left.

"Three or four years before the attack, a man came to the church from the nearby mosque," continues the photographer "He was delirious and was holding a hatchet. He killed a man and injured two others, then headed for another church where he was stopped. Once imprisoned, he was declared incapable of consent and has never been tried. "Less than three months have passed between the attack in Alexandria and the fall of Mubarak. We arrived in Alexandria as Mohammed Morsi, the candidate supported by the Muslim Brotherhood, was delivering his inaugural speech as the new President. For weeks, the most extremist factions had been imposing laws and practices that have not been seen in Egypt for decades."

"Yesterday I went to the beach and there were some seven- or eight-year-old girls wearing a veil," says a girl who asks not to disclose her name. "I don't know what will happen, but I fear that for us Christians there won't be any room in Egypt."

The fears of Alexandria spread all the way to Aswan, the last major Egyptian town before Sudan. "The fundamentalists want to convert us to Islam because they feel it's their duty. The Sheikhs offer young boys money to marry our women," say the men of Aswan in front of their nodding wives.

"They spray women in their faces, undress them, take pictures and then blackmail them. Other times they rape them and get them pregnant, so that they will be forced into marriage. We don't let our wives and daughters go out by themselves. If a Christian woman disappears from Aswan, we try to track her down before conversion, otherwise we won't see her anymore." The Christian community is saturated with these stories but nobody has the guts to name the people involved or produce evidence. What they claim is not verifiable, but this does not prevent terror from spreading. Even guys are targets. Some people are offered money and wealth, then disappear. Others are attracted by a business or an investment offer, then go into debt and consider conversion the only possible solution. There are also cases of Muslims taking possession of land belonging to the Christians because they know that the courts will allow them to do that. We have been living in fear for 1400 years, since Islam came to Egypt and Nubia became Muslim," they conclude. On the July 30th 2013, a coup by the Egyptian army overthrew the government. President Morsi was arrested and the Muslim Brotherhood was banned as an organisation. Subsequently, in May 2014 the elections were won by General al-Sisi – commander of the armed forces – with 96% of the votes. The Egyptian Copts have supported the new President, convinced that his election would put an end to religious violence.

This is not the first time the Christians of the East have been supported by a military regime. It had already happened with Mubarak and Saddam Hussein in Iraq. In 2003, after the Anglo-American invasion overthrew Saddam, the lack of an established power fostered the spread of sectarian violence across Iraq.

In Baghdad, under a porch, dozens of vendors are exhibiting books, photographs and postcards of a city that everyone would like to get back. It is al-Mutanabi, the book market. A dusty pavement rescued from the road traffic divides the ranks of old abandoned buildings. An ancient coffee shop remains to serve as the corner between the street of the mosque and the madrasa. Nearby we find al-Sarai, King Faisal's palace, ashamed to show us its skeleton. "Baghdad is no longer a city, it's only a shabby hotel," sighs Saad Said, who was once a poet and is now a homemaker. A district called Karrada, in the heart of Baghdad, hosts the Syrian-Catholic Cathedral of Our Lady of Salvation, that became the theatre of a massacre on October 31st 2010. "That day was colder than usual, I was not well and I decided not to go to church. Since then I have

not seen my wife and my two children again," laments Adib Abu Elia, a 75-year-old. A group of fundamentalists of the Islamic State of Iraq, the Iraqi wing of al-Qaeda at the time, broke into the church and massacred fifty-eight Christians. Abu Elia lost his family and became "the father of martyrs". Since then, he has lived in a clinic for the elderly. "One of my sons was behind the door. He was the first to die."

Abu Elia prayed daily to be moved to France, where the families of the other victims had found shelter. "For a while, I was the father of the martyrs – the elderly left alone. It took only a few months to be forgotten and find myself left in silence with my demons and my photographs. Luckily I have Muslim friends who come to visit me," he says.

"A country is like a man: the result of the baby he once was. If we do not discipline Iraq immediately, it will never change," reflects Hanna, a former army officer under Saddam's regime. Hanna is a 60-year-old man whose behaviour reveals his military past. He fought in the war against Iran, in Kuwait, and in the first Gulf War. He lived in Mosul, a city in the Northeast that underwent the infiltration of al-Qaeda after 2003 and is now under the control of Isil. Like many other Christians, Hanna and his family took refuge in the autonomous region of Kurdistan. Driven from their homes in and around Mosul, the Christians found a new neighbourhood in Erbil, Ainkawa, made especially for them. Thanks to its pubs, alcohol resellers, supermarkets, luxurious hotels and beauty centres, Ainkawa became known as 'the bar of the Middle East'.

"In 2003, we could not know where the bombs would fall. In the following years we could not know who was going to kill us," recalls Ra'id. "I was born in Qaraqosh, the capital of Christianity in Iraq. Saddam decided to exterminate the Kurds and they used the Christian homes of Qaraqosh as a hiding place. So I moved to Baghdad with my family. It was 1993. Ten years later Saddam wasn't there anymore, but the war for the control of Baghdad had begun. I lived in Dora, where the Sunni fundamentalists attacked the Shiites first and then the Christians," relates Ra'id. "In Baghdad, I used to work in a centre for poor children. One day I was threatened with death if didn't close it. Two weeks later it happened again and I gave in. Meanwhile in Dora, whoever sold or consumed alcohol was killed on the street. They killed women because they were wearing jeans. One day they killed all the barbers in the neighbourhood because cutting one's beard is considered a sin. On a Sunday, they attacked all the churches in the neighbourhood. A few days later I found out that my neighbour was building home-

made bombs: he blew up his house and died. I kept on receiving intimidating letters, until I realised I had ended up on a list of terrorists' targets. So I came to live in Ainkawa with my wife and my son. After three years my second daughter Emi was born." Ra'id is as seraphic as if he was reciting a novel, while Emi crawls on the carpet. Noura also moved from Mosul to Ainkawa in 2008, with his father Noel and her mother Sebaba. "We had nothing left and we came to live in Kurdistan because the Kurds respect us and they love democracy. We chose Erbil over Europe because we are the children of the first Christian martyrs and we will not leave our lands."

Noura studied to be a pharmacist, while her sister did not get the same opportunities. "She was killed in 2004 because she worked for an American company. She was twenty-six years old. At the funeral, my father asked God to forgive the killers because they did not know what they were doing."

This phrase led to Noel being kidnapped twice. "The first time I was held just for a few hours. The second I was with six other prisoners," chimes in the father "One day they beheaded one of them, a Muslim, and they said 'See? It wouldn't take much to kill you too!' I replied that it wasn't their decision, it was God who decided. Shortly after, the Kurdish Peshmerga launched a blitz and freed us."

A few kilometres away from Mosul lie the lands of Qaraqosh, al-Qosh, Telskuf and Bartella. Here, Christianity has centuries-old roots and the Assyrians implanted the capital of their empire, Ninive. In August 2014 these villages fell into the hands of Isil and 100,000 Christians fled to Erbil and surrounding areas. Two years earlier, Qaraqosh was already living in fear of a fundamentalist attack. The main entrances and places of worship in the city were patrolled by Christian voluntary militias, armed with Kalashnikovs and wearing a cross around their necks. "Under Saddam's regime no one was interested in the religion of other people. Now I do not trust anybody anymore," says Aous, a young Qaraqosh who now lives and works in Erbil.

John was the only one of the three Yacoub brothers still living in Telskuf. A few months after he retired, John's only goal was to find a buyer for his properties to be able to join his brother George, who fled to Beirut in 2010 with his wife Fadia and their five children. George and John were very close: two floors and a garden full of flowers are being missed hundreds of miles away. "Sometimes I dream of the night when we closed

the gate and walked away," recalls Juliana, the eldest daughter. The Yacoub family now lives in the Christian neighbourhood of Baouchriye, in the eastern suburbs of Beirut. Seven of them share a small apartment with two bedrooms, a living room, a kitchen and a bathroom. "In Iraq, I could afford to be the only one working. In Beirut three of my sons are cashiers and my wife works as a seamstress, otherwise we wouldn't earn enough". They are waiting for the documents they need to emigrate as war refugees either to the U.S., where they could stay with George's father, or to Australia, where Fadia's brother lives. "The quality of our life has deteriorated since we have been in Lebanon," they say "but we could not stay in Telskuf. Every day we Christians were victims of attacks and our children could not go to school or college anymore. We have left everything to find, at least, tranquillity."

We crossed the Masnaa border between Lebanon and Syria in January 2014. Leaving behind us forty kilometres and nine checkpoints, we arrived in Damascus, where the map of the city is a canvas where military green has taken over. The shops are open, the restaurant tables are busy and lights and constables control the traffic. We can hear the sound of explosions and shootings coming from afar. Bab Touma is the Christian Quarter in the Old Town. It's the antique fabric dressing the market, where old lopsided houses overlook a maze of narrow streets and industrious residents roam between shops and stores, acting a normal life. It is January 7th, the Armenian day for the commemoration of the dead. In the cemeteries, people pay homage to the dead with prayers, soft drinks and snacks.

"The escape of the Christians began well before the war. Some decades ago in Syria there were 230,000 Armenians of the 4 million people, now there are 17 million inhabitants, of which only 80,000 are Armenian. But not only the Christians are affected by this tragedy: Muslims suffer even more, because they are the majority," says the community priest between handshakes.
"Syria has a long history of co-existence, it was impossible to predict it would have entered the war. I keep on repeating that there is no persecution against the Christians, there is a fundamentalism that goes against all the moderates," reflects the Syrian-Orthodox bishop of Bab Touma's patriarchate. The portraits of Yohanna Ibrahim and Bulos Yazigi, the two bishops in the province of Aleppo kidnapped on April 22 2013,

tower over us on the facade of the building. "Our people are scared because they think that if even a bishop could be kidnapped, who knows what can happen to them. There are those who want to take up arms and defend themselves and those who want to leave Syria. It is difficult to dissuade them when there are 3,800 Syrian families displaced, bishops and nuns are being kidnapped, entire cities are held hostage and so many stories of crimes against Christians are told."

In Damascus, the already precarious sense of security is shaking on the front lines, where the remains of streets and buildings have become barricades. The Greek-Orthodox school of St. James is located only 700 metres far from the fighting in the Joubar district. "The mortars fell even on our yard and many pupils are no longer coming to school," says the headmistress "Children are talking a different language, they use military terms and draw war scenes."

The register of victims, refugees and displaced persons has to be continually updated. Millions of Syrians have fled their cities, which have been destroyed by the regime through bombings or looted by rebels. Many move to the capital, wrecked, clinging to their own bodies after they've lost everything else. "There was a public oven. I saw men throwing the employees who were working there into the fire because they considered them servants of Asad. I saw dozens of people slaughtered and their heads hung on a tree like Christmas decorations. I saw men slitting the throats of some children, whose mother's only crime was her attempt to hide them. Is this the freedom they want?" asks a woman who has just run away from Adra, a town a few dozen kilometres from Damascus. She is sitting on a chair in the courtyard of the pharmacy in the Santa Croce district. A ray of sun beats down on her, her eyes drown in tears as she admits sending her children to rummage in the trash. "They managed to escape with me because I taught them a few verses of the Qur'an to be recited out at the checkpoints."

The main street of the souk ends in front of the Umayyad Mosque, the fourth holiest place in Islam. In the inner courtyard, people relax while waiting for time to go by, and wonder which God would ever want to destroy this sense of peace.

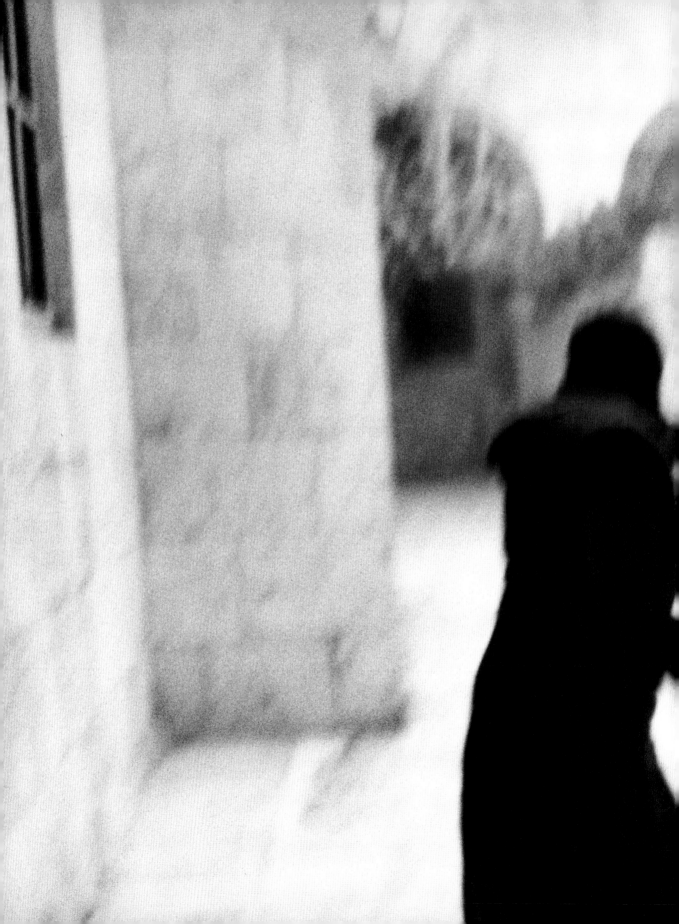

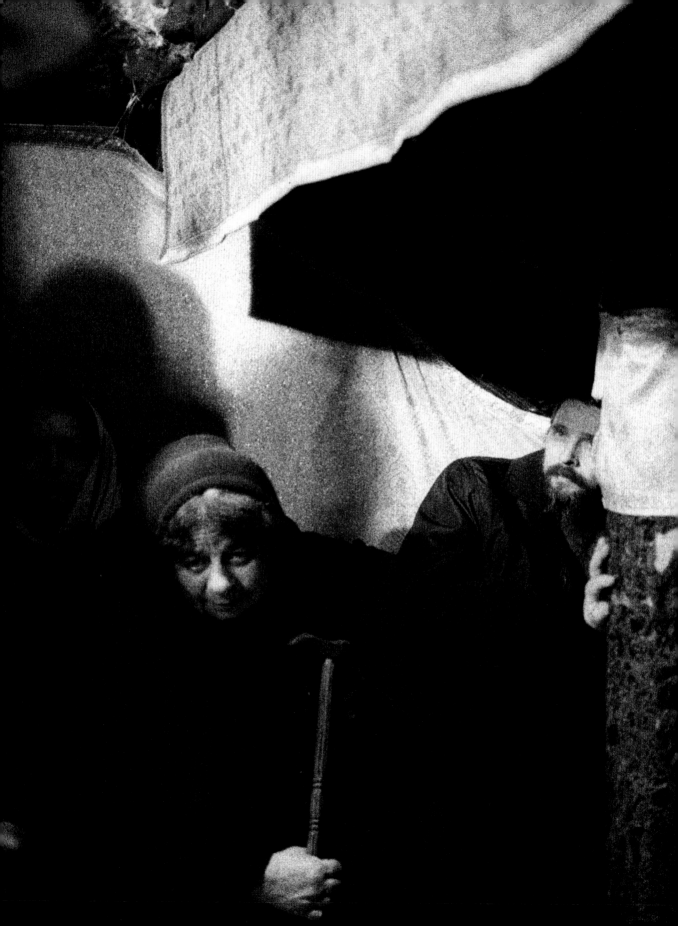

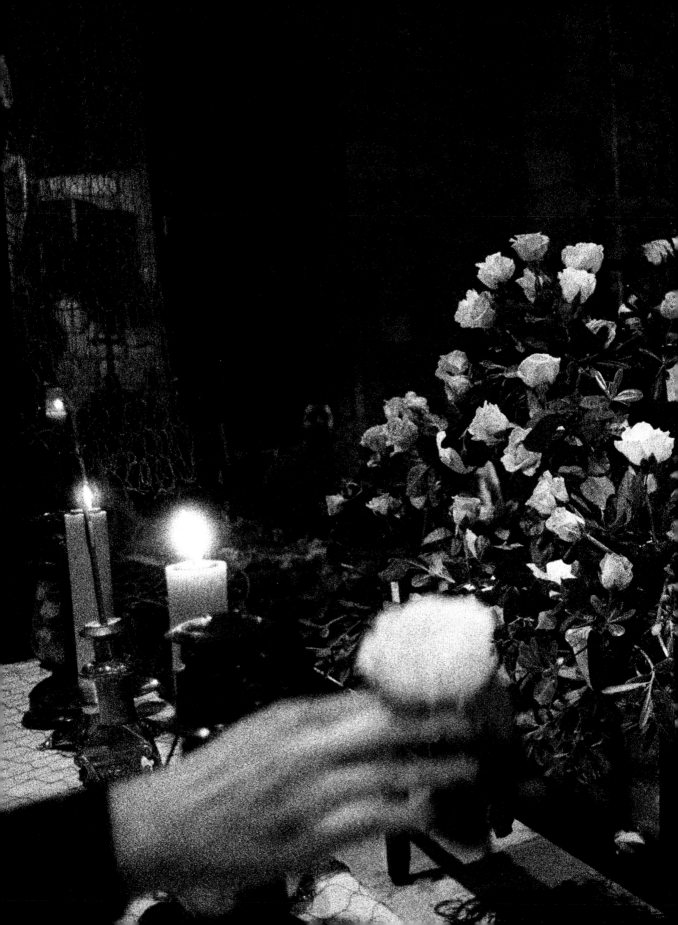

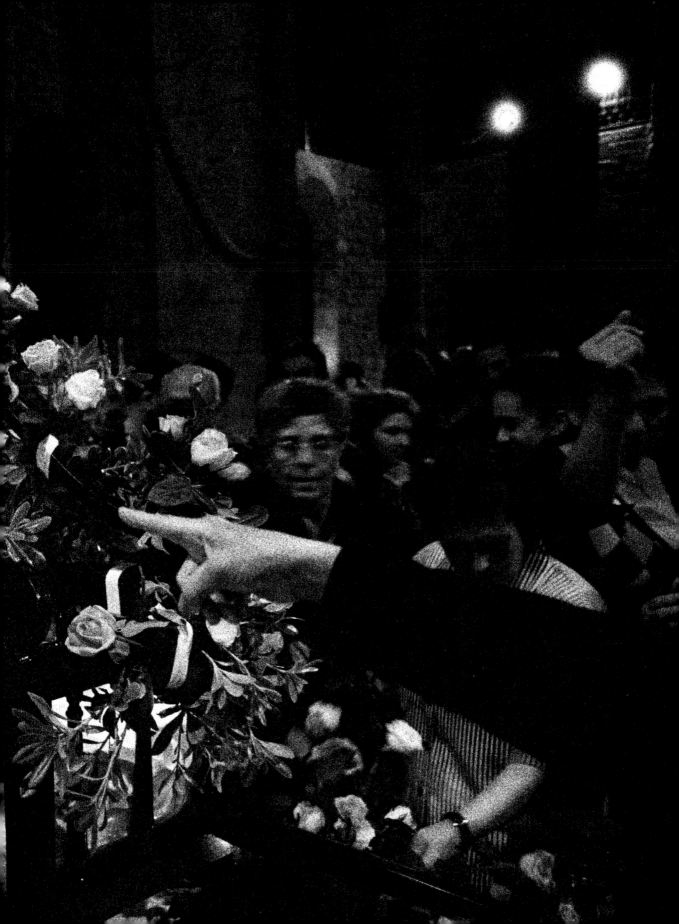

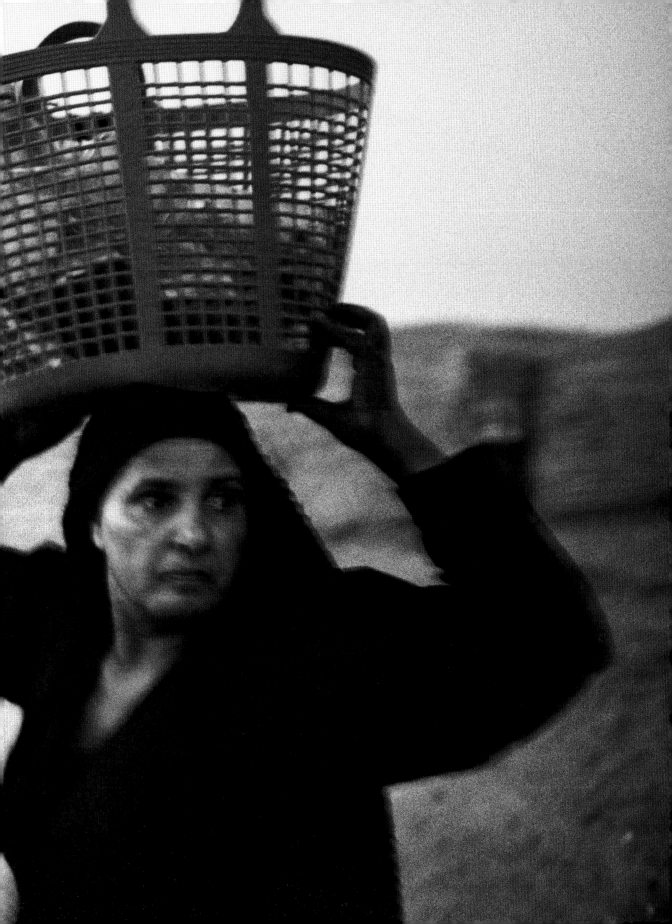

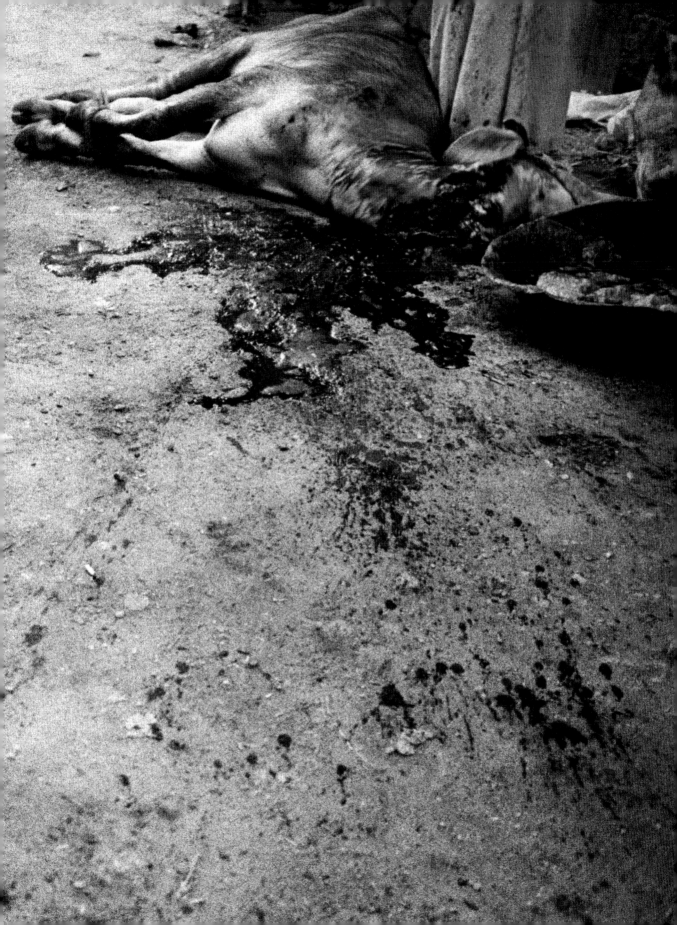

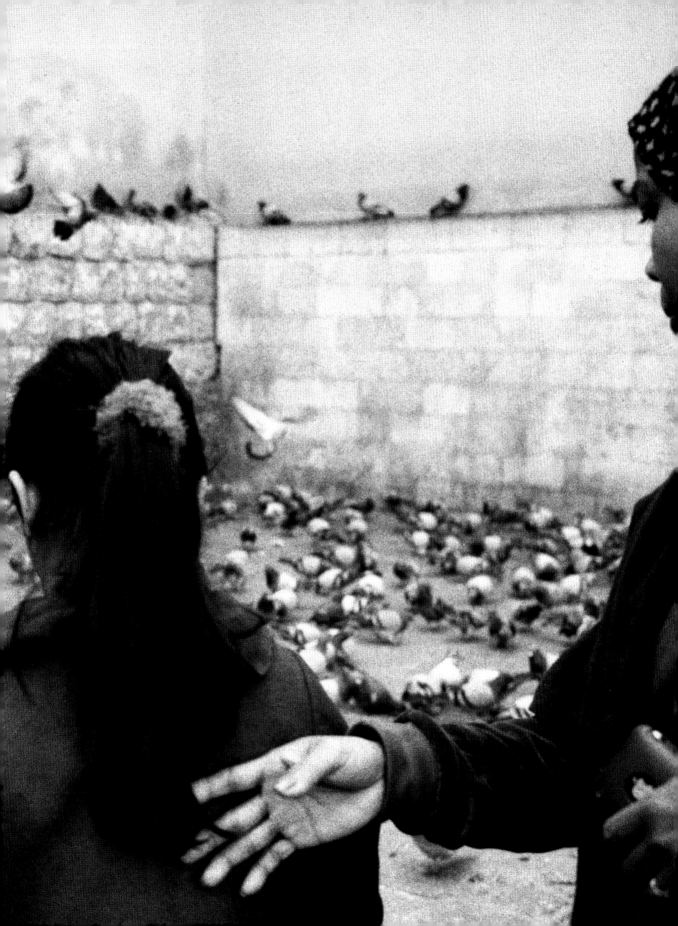

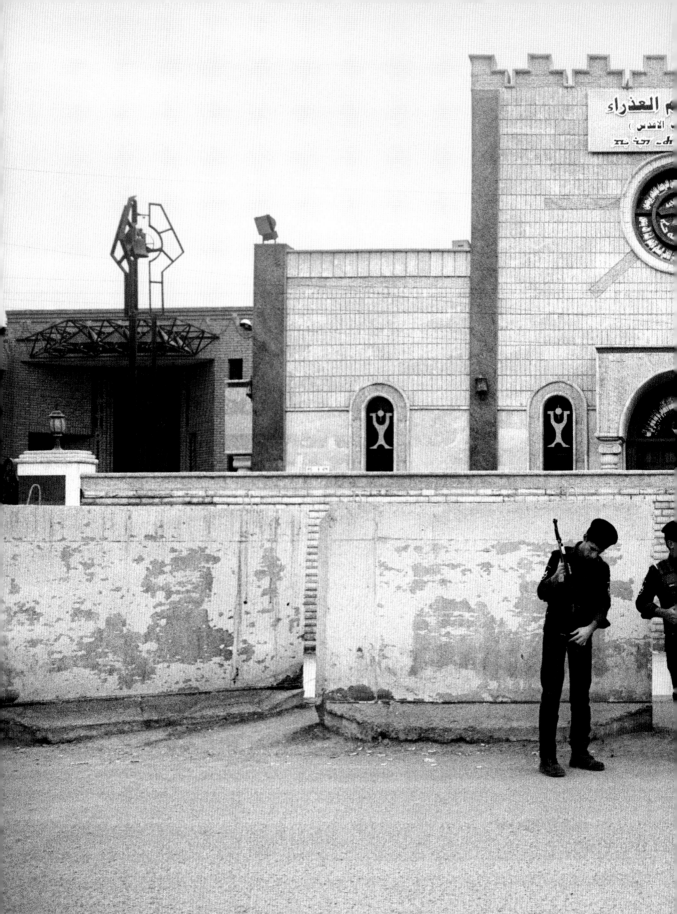

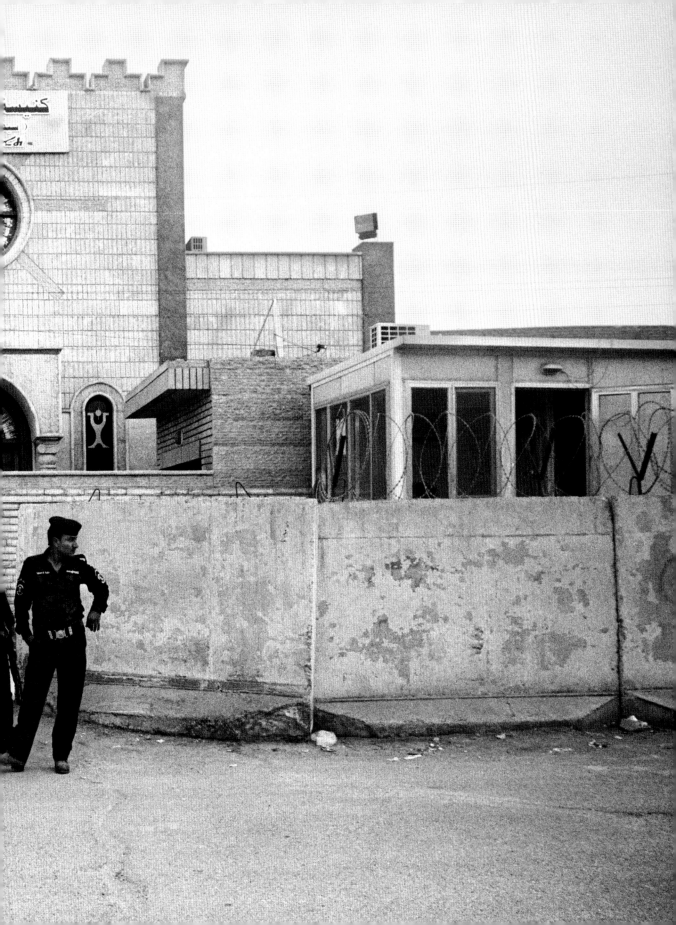

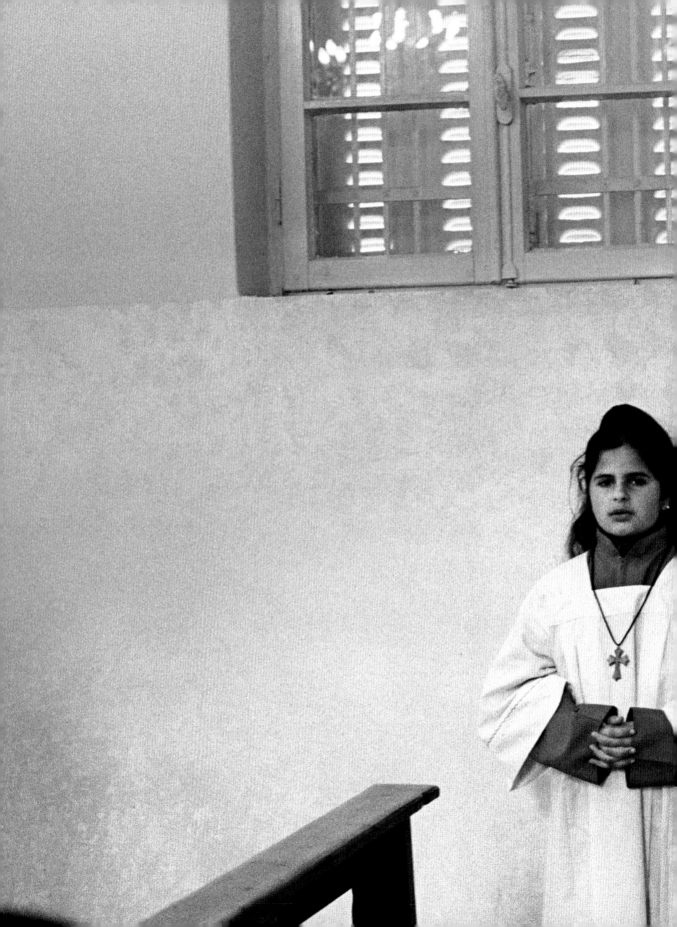

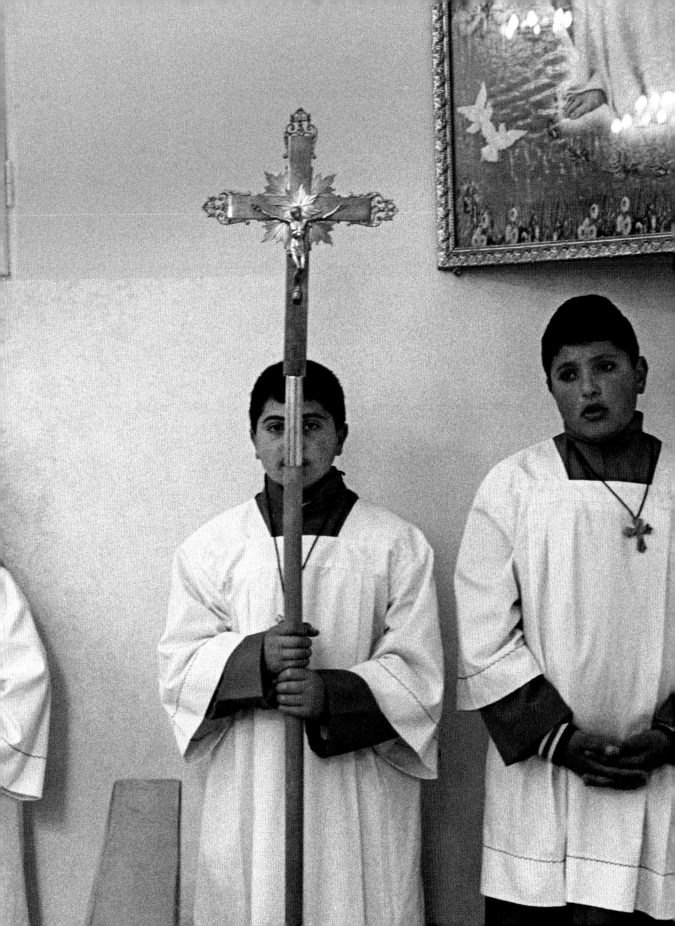

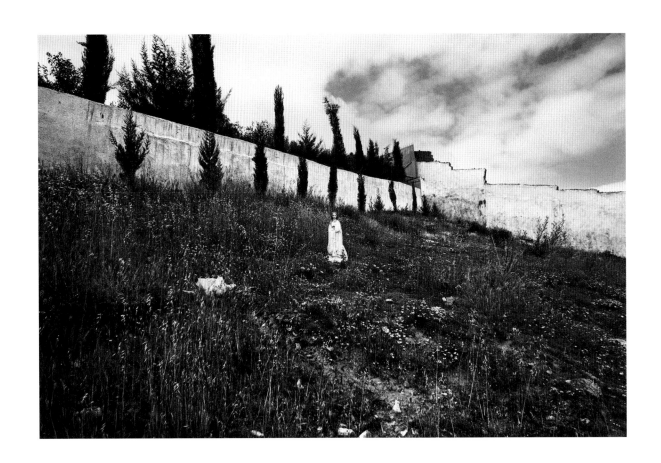

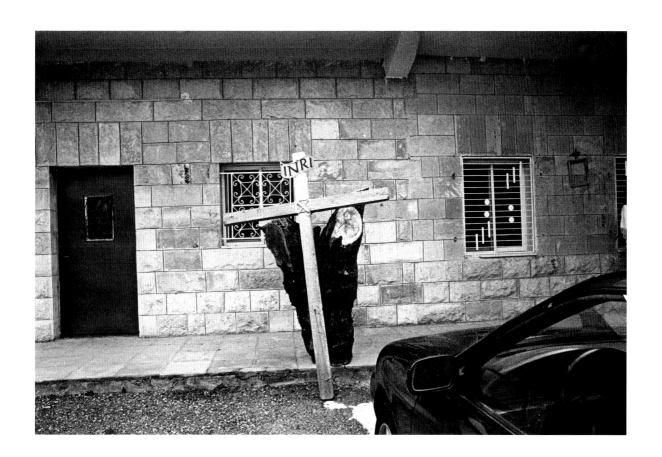

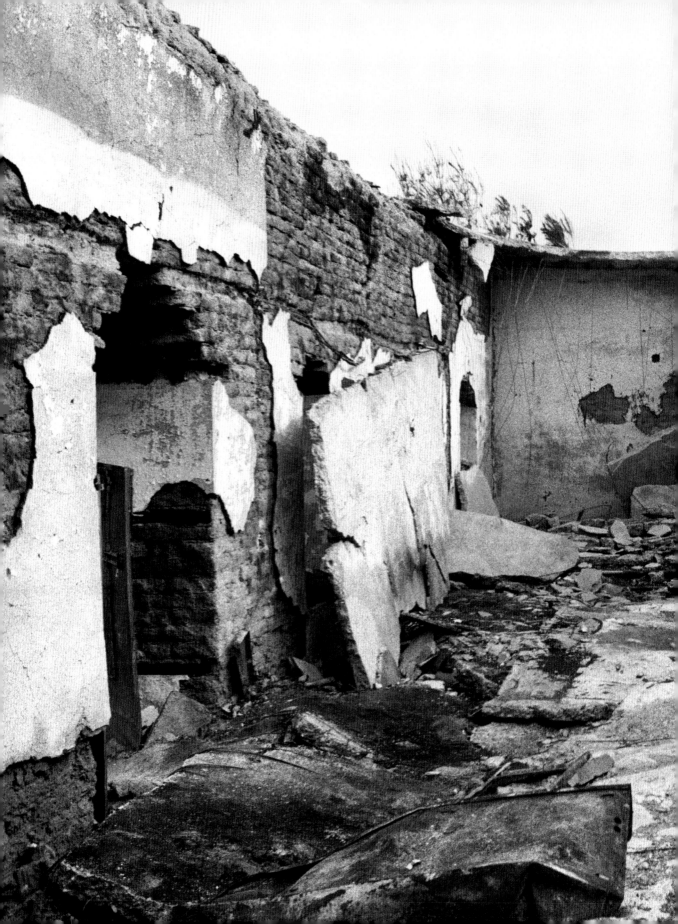

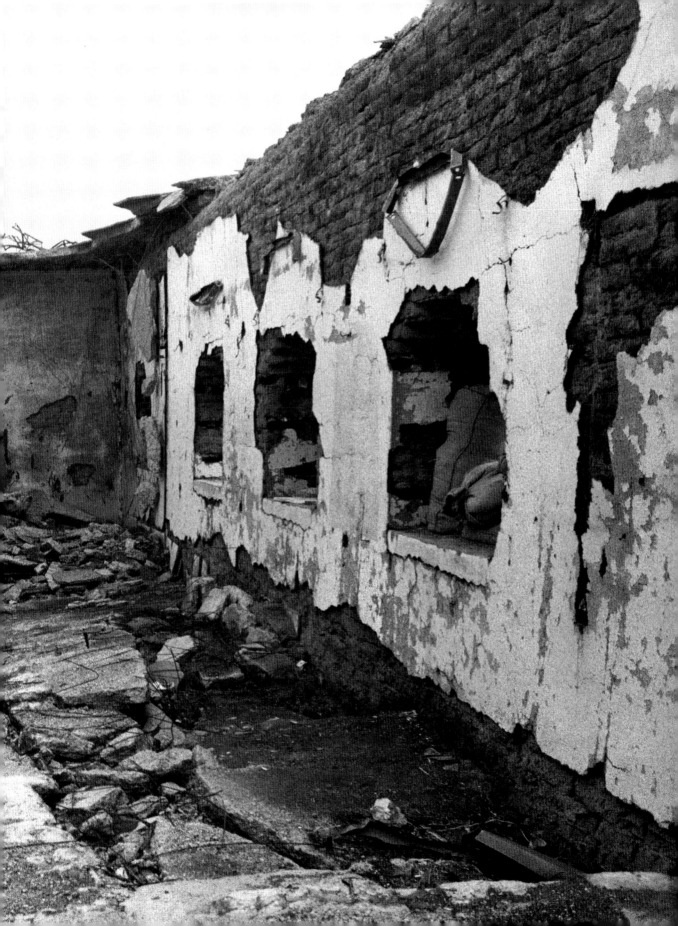

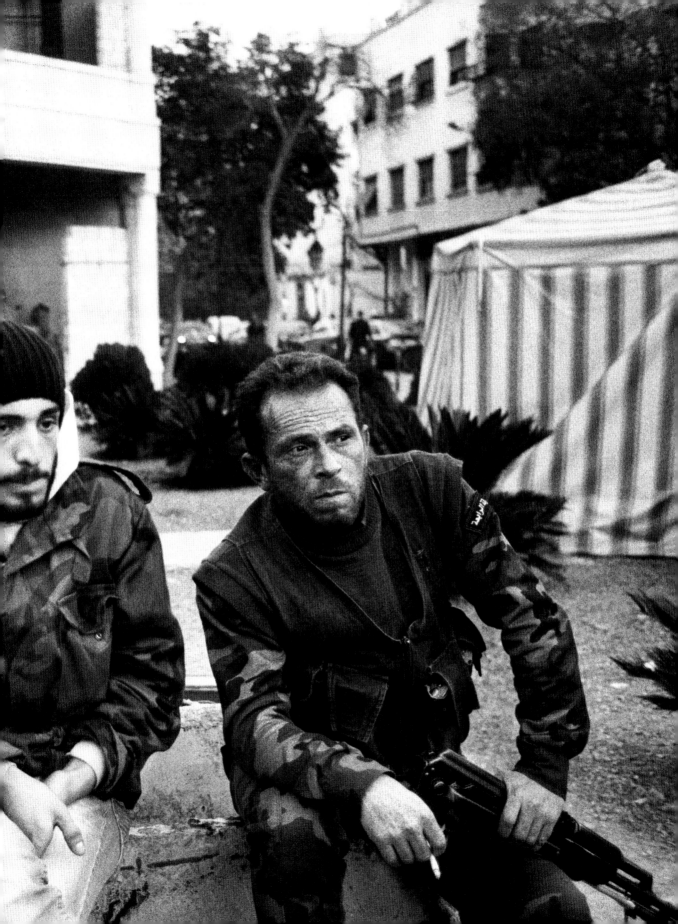

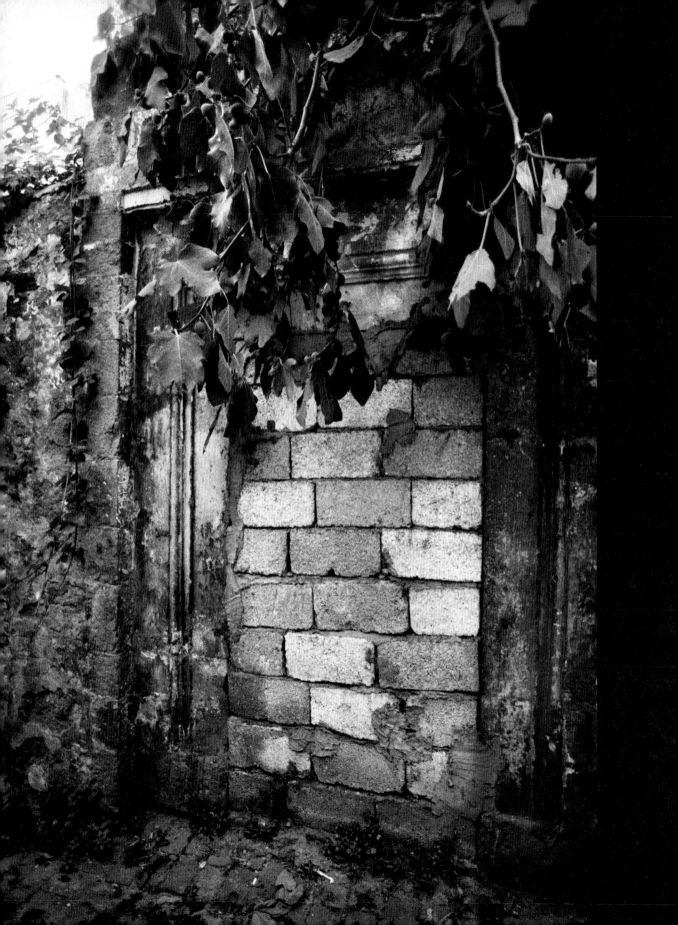

borders

Divisions in the Middle East are religious, political and physical. A 700-kilometre wall separates Israel from the Palestinian Territories. It was built in 2005 under former Israeli Prime Minister Ariel Sharon. "In 2007 the wall arrived here and after a few months I found myself alone," says Abu Samir, a 60-year-old man with diabetes and two bypasses. Abu Samir lives in Jalame, on the West Bank, three kilometres as the crow flies from Mouqeibila, in Israel, home to his wife and four children. Abu Samir is the last remaining Christian to share isolation with his Muslim countrymen. "My father came from Mouqeibila. Many years ago he decided to move to Jalame, where he owned land. It was no problem to go from one country to another until the checkpoints were set up."

The construction of the wall has brought with it new rules and has turned a few miles' journey into an odyssey. "My daughter went to school in Mouqeibila but the soldiers didn't always allow her to go, so she started sleeping at her grandparents' house. Another daughter was studying at the University of Jaffa, near Tel Aviv. She requested an Israeli identity card but couldn't obtain it because her residence was in Jalame. She had to move to Israel. "Since the wall has taken away from us every opportunity for work and development, even my children have moved to Israel. Anyway, we could always visit each other often, we said. My wife stayed with me, but soon after went to Mouqeibila to stay close to our children and had to find a job to get the Israeli documents. I was left alone with my land and my ailments." Samir Abu cradles his tractor and looks forward to the weekend when his family will come to visit. "If I could go back in time I would do anything to convince my husband to follow us. Now, even if he wanted, they would never give him the papers. We are in this situation because governments do not think about the consequences of what they decide," cries his wife Sara. She and her three children share an apartment with much less comfort and space than the home they left in Jalame.

"I miss my husband, my home and the simplicity I enjoyed in Palestine, I cannot find it here. I am a Christian and family is important to me. It's hard to live without my husband, not being able to ask him for advice and not knowing how he is. But if I decided to leave Mouqeibila I would lose the documents and I would have to leave my children on their own."

The history of the Israeli wall has a repetitive script; it radically changed life in Palestinian cities, fomenting hatred towards the Israelis. Beit Jala is a Christian village near Bethlehem where families support themselves through agriculture. On the nearby hills, the Israeli settlements of Gilo and Har Gilo stand out. Built in 1967 as military bases, they became real villages – first for the families of the soldiers, then for the settlers. The Israeli government is planning to extend a portion of the wall to include them. "If Israel builds the wall, it will be the end for the families of Beit Jala. No negotiation would work," states Xavier, son of one of the fifty-eight Christian families in Beit Jala. The bulldozers are still waiting for the Israeli Constitutional Court's decision on the legality of the project. "As the Palestinian authorities and the church can do nothing against the Israeli government, we organised a mass in the olive groves every Friday afternoon. In the olive grove of Gethsemane, Jesus Christ was alone with olive trees, now we are here to try to save them".

On the green hills of Cremisan, a Salesian monastery juts out, famous for its wine production. When Israel announced its intention to extend the wall, the Salesians pushed for the monastery and vineyards to be left in Israel because they feared that it would be much more difficult to export the Cremisan if it ended up in the West Bank. "After a Vatican intervention, the monks changed their position," Xavier continues. "The Cremisan will remain a Palestinian product and the monastery has joined our resistance." A final judgment of the Supreme Court was delivered in April 2015, stating that a new portion of the wall cannot be built, meaning that Cremisan's olive trees are safe. Away from the wall, beyond miles of valleys and forests where heaven and earth alternate, lies the Gaza Strip. There, almost two million people live on a strip of land measuring forty kilometres by six. The only point of access is the Erez crossing, controlled by the Israeli authorities.

We arrive in January 2013, one month after the end of the Pillar of Defence operation, one of the many wars between Israel and Hamas since, in 2007, the Gaza Strip came under the government of the fundamentalist movement and under the Israeli embargo. "At the time of the Byzantine Empire, Gaza was entirely Christian, the port was flourishing and the city was one of the most important in the Mediterranean. Now I talk about Gaza and I can only think of the word 'humiliation'." Father George is the pastor of the Catholic community in Gaza, 113 people out of about 1300 Christians. He is from Argentina, a 36-year-old guitarist and former rugby player, and is in charge of the parish with Father Mario, from Brazil, two Argentine nuns and another Brazilian nun. They are all South Americans, because Israel does not allow Arab clergy in Gaza. For several months the U.N. has recognised Palestine as its unofficial member thanks to the Argentinean vote and since then "every time I go and I leave the Strip, Israeli soldiers interrogate me, search me, humiliate me," says Father George. The Christians say they undergo forced conversions, as well as restrictions of movement and thought because of fundamentalism, but the Palestinian cause also cements the union. "I have a Jordanian passport that would allow me to leave. I don't do it because of my family, especially my children," says Anus, a hospital employee at the Red Cross, that together with Caritas is the focal point of the Christian camp, the Christian Quarter. "Hamas is radicalising Islam but we and the Muslims have always lived well together. In Gaza, we do not distinguish, we are Palestinians fighting Israel," assures Anus. Father George's phone rings constantly, with family men asking for his help to solve problems within the neighbourhood. This time it is a boy that said one word too much to a Muslim girl. The remedy to the offence is for them to marry, which means conversion to Islam. Other times young Christians are offered a job in exchange for their conversion. Forced by hunger, many accept and the community loses members. "Sometimes I wonder why many decide to stay Christian in Gaza. I mean, it would be much easier to surrender to Islam and live like everyone else," snorts Father George. In Gaza there is lack of work, money, security, freedom. And the bombs falling from the sky are not aware of the religion of their targets. In August 2014 yet another war between Israel and Hamas caused more deaths. Dozens of young Israeli soldiers have not returned home and thousands of Gazan families have honoured their grief by joining the resistance and martyrdom touted by Hamas. Gaza is an open prison and religion is its jailer. The more compelling

the control exercised by the power gets, the more difficult life is for the priests on the border. Father Milojad Vaghinagh is the guardian of the Armenian parish of Tabriz, in northern Iran. Armenian-Syrian by birth, Father Vaghinagh has been in Tabriz for a little more than fifty days when we meet him. He has a perimeter of action that encompasses 800 Armenians, four churches and many schools in a city of a million and a half inhabitants. An ancient Russian colony that became Ottoman later, mother of the constitutional revolution, Tabriz cannot escape its reputation as a city of intrigue. With a gait somewhere between priest and soldier, Father Vaghinagh shakes the long blue robe that hides his slender hands and breaks the silence. "If foreigners come, my first task is to understand whether they are spies or not. I walked past you twice, I watched you carefully. You are not spies. Come in." The parish wall is two metres high and the front door only opens from the inside. "My predecessor had a gun. It was given to him by the Iranian government after the Turks tried to enter by force. Now I have that gun and I'm not ashamed to say that I am ready to use it if we were to be attacked. 'Turn the other cheek' is not written anywhere in the Bible. It does say we have to defend ourselves." Everyone is required to inform the regime of new foreign arrivals in Tabriz, about the behaviours that are conducted in the city and the conversations. "We are a minority and this is a city with many Turks who have not forgotten the vengeance of the Armenians after the genocide of 1915. Of course we have to ask for protection. And the protection of the regime has a price. If Khamenei declared war on Christians, in a single night none of them would be left alive throughout Iran," Reza, a young Armenian from Tabriz who tried to escape a life under blackmail, admits bitterly. "Everyone minds everyone else's business. If I spend too much time at the internet point or talk to a stranger, someone will warn me that it's better not to. I do not want to grow up like that. I want to pass that damn border and start living." Reza is still in Tabriz, unlike Father Vaghinagh. He successfully applied for transfer to Beirut, because the atmosphere of suspicion was not ideal for talking about Christ.

The highway from Beirut airport spews out into the centre where the lights of the al-Amin mosque enhance the blue domes trapped between the minarets. Next, the seagulls court the bell tower of the St. George Maronite Cathedral. The most beautiful mosque and the largest church share the stage; it resembles a challenge to whichever is

closest to God. Beirut is divided between Muslims and Christians and, back in the old days, the green line separated the West from the East. Now that there are only some traces left of it, demography has not changed much and everyone still thinks in terms of "us" and "them." Father Jean's office is in Achrafieh, the Christian Quarter. He is in charge of receiving and sorting the hundreds of seminarians who come to Lebanon every year for monastic training. "I was born in Mazraat el Chouf, a village in the Chouf mountains among the Druze, followers of a religion derived from Islam," he says. "It's close to Mukhtara, the birthplace of the Jumblatt family, the historical leaders of the Druze. Christians and Druze have always lived together in peace and when civil war broke out Kamal Jumblatt ordered the Chouf to remain out of it. On March 16th 1977, however, Jumblatt was assassinated, probably by the Syrians, and the Druze decided to take revenge on those who were their enemies in that war: the Christians. They descended en masse to Mazraat and executed fifty-six people. Since then, my country has been empty." "In a homily a few years ago," continues Father Jean, "I sent an invitation to forgive our assassins. A few months later I had the satisfaction of knowing that one of the mukhtar (*community leaders, author's note*) of Deir al Qamar has recognised in public that we Christians are better than the Muslims because we forgive. "Dozens of small villages are scattered on the plateau of the Chouf, where you can still find stunted cedar forests. Many of my neighbours have flown to America or Australia, others live in Beirut. Some keep their Mazraat house for holidays, but most of them haven't shown up since 1977," says Father Jean as he drives along the trail that leads to the village. Thanks to Father Jean, the road was re-connected. He has also rebuilt the parish and organises Sunday dinners in the village to reinvigorate the community. "Lebanon is a beautiful place, look at that view! Listen to the silence! There is only one problem: the Muslims!" laughs George, one of the few who answered the call of Father Jean to spend a Sunday together. Almost all of the Christians there are lawyers, teachers, or dentists who speak English or French fluently. "Many Christians, especially the younger ones, don't feel like going back because they don't want to be a minority and live in poverty," confides Father Jean. "They don't trust the Muslims and are not willing to pay a small sacrifice to spread the word of Jesus. They have forgotten the meaning of Christianity."

After mass, a lunch washed down with copious glasses of whiskey and a stop to buy cheese from the local dealer, it's time to go back to Beirut. "Many think that the Christians will leave Lebanon. But Lebanon would no longer have any reason to exist. Even the Muslims have understood that and if the most radical fringes can be isolated we will succeed. We will live in peace!", declares Father Jean, and it's not clear whether he's talking to us or talking to cheer himself up. The North of Iraqi Kurdistan is a mountainous region dotted with small villages which keep their warm atmosphere. Far from the major roads, small isolated communities grow and seek the priest's advice and help. In the villages of the Middle East, the parish priest is a guide. "In 2004 I left Mosul to go to Rome because Father Rahho, my spiritual mentor, had convinced me to enrol for a PhD," says Father Samir. "I wanted to write my dissertation about St. Ephrem, one of the masters of sacred music. Then the terrorists killed Father Rahho. After a few months they killed another priest of Mosul, Father Ragheed, and the Christians fled to the mountains of Kurdistan. After years of suffering, a Christian community was being rebuilt. We priests must be close to our people, right? So I left Rome and never paid tribute to St. Ephrem with my dissertation." Father Samir lives in Einiske, in a house he shares with his mother. "When Saddam was ousted," recalls Father Samir, "Iraq was out of control. Bands of kids entered the unattended weapon storehouses of the army to steal guns and rifles and sell them on the black market. A gun costs four and a half dollars. I remember because I bought one. We had hosted wounded American soldiers in our bishopric and the terrorists had sworn to take revenge on us. We could not pretend nothing had happened. One night we heard a group of people up the hill and we started shooting blindly. The next day we received a letter that accused us of having killed one person. I don't know if it's true, I don't even know if it was me who killed him. But since then there has never been peace for Christians in Mosul."

Einiske, Mengesh, Araden and other small towns in the mountains above Dohuk have become the new home for many of them, while hundreds of families have emigrated to Europe or the United States – especially in Detroit, in an area that has been nicknamed 'Chaldean city'. They send money to their relatives who have stayed, with the result that young people often don't need to look for an occupation. Whoever is left can observe their faith in peace, unlike the emigrants, lost in the rhythms and secularity of

Western society," says Samir. Being a priest on the border can be a deadly risk. Father Andrea Santoro was the Catholic parish priest of Trabzon, the last Turkish town before the Georgian border. Father Santoro was in charge of the church of Santa Maria and devoted himself to the co-existence between Christians and Muslims. In 2006, a young man shot him in the back and killed while he was sitting on a church bench. The efforts for interreligious dialogue died with him. A priest who asked to remain anonymous opens the door of the church. "Political leaders and religious Turks want to defend Islam from Christianity and preclude any possibility for agreement," he explains. "Our identity is shown in our papers, but the Catholic and Orthodox religions are simply not recognised. We are foreigners. And foreigners are not wanted in Trabzon." The priest speaks of continuous controls and attacks from nationalist fringes towards the Christian minority. We go with him to the office where the mukhtar was summoned due to some neighbours' complaints about the church being dirty and messy. "This is ironic because I am the only one left to live there," he smiles. He shows us the old Catholic cemetery, now a tangle of abandoned brambles, and the cross that perseveres on the door of what was once a church and is now a car park. He looks around, takes his precautions and invents a coded body language to communicate with us in public without being understood by others. Trabzon was the last Byzantine city to fall under Ottoman control. What's left of those times is the church Aya Sofya, less famous than the homonymous basilica in Istanbul, which was then transformed into a museum. In July 2013 this one became a mosque and the frescoes that decorated it were scratched or covered with plasterboard. In the same period, some mullahs and the more conservative politicians started a campaign to convert even the Aya Sofya in Istanbul into a mosque.

warriors of god

Christianity was born in the Holy Land, but today Christians make up only 1.5% of the population. "It is the duty of these Christians not to emigrate but instead to join the struggle of our people," insists Rifat Kassis, founder and President of Kairos. "In Palestine, there have never been distinctions between Christians and Muslims. We are all Palestinians." Kairos is a Christian association which started with a move by Kassis and another 3,000 authors. In a document, they invite institutions and believers to condemn "the Israeli apartheid" and define the Israeli occupation of Palestine as "a sin against God." The text encourages scholars of Judaism, Christianity and Islam to spread an essentially theological vision of the sacred books and separate religion from politics. "We should establish that the concept of the promised land upon which Zionism is based has a metaphorical meaning that is ideological and not real," says Kassis. "God was not a surveyor busy drawing borders."

The memory, the properties and the holy places of Christianity are fragmented. December 25th is Christmas for Catholics and Protestants, January 6th for the Orthodox and, eventually, it's the turn of the very few Armenian Orthodox in Palestine who have their celebration on January 23rd. On the square in front of the Church of the Nativity in Bethlehem, a huge decorated tree illuminates all celebrations. In 2002, during the Second Intifada, the Church of the Nativity was besieged for thirty-nine days by the Israeli army. The soldiers tried to flush out dozens of fighters who sought shelter inside the church. For over a month the bullets whizzed past Baby Jesus' crib, and the world realised what Christians already knew: in the Holy Land there is room for a third voice. "We come after the Jews and the Muslims, who consider us enemies. But the reality is that Christians have lived in this land for two thousand years and we're guarding it," says Father Elias, parish priest of the Latin Vicariate of Nazareth. The city where Jesus was born is inhabited by Christians, Arabs and Muslims. The Jews preferred to abandon it and built Nazareth Illit, the city's semitic counterpart, seven kilometres away.

As soon as we arrive we come across the church of the Annunciation, nestled in the fascinating maze of stone stairs, mosaics and colours that play upon them. Alongside, a black sign promises revenge for what happened in 2008: "The Muslims of Nazareth asked permission to build a mosque next to the church," says Father Elias. "The mayor and the Vatican were against this so the Muslims occupied the ground with prayers and mass demonstrations. After a while, we Christians reacted. Many fights broke out and eventually we managed to prevent the building of the mosque." Between Syria and Turkey flows the river Orontes. Two millennia ago, Paul of Tarsus, one of the famous narrators of the life of Jesus, travelled along its banks while preaching all the way to Antioch. In the city of Antakya, the current name for Antioch, churches, mosques and one synagogue don't stand in each other's way. Islamic, Jewish and Christian symbols decorate walls and streets and the multi-religious atmosphere is a fertile ground for proselytism. Antakya is the perfect place for free Christian churches, such as the one started by Abdullah and Elmar. Abdullah is the guardian of the nearby hospital, Elmar takes care of her three children and of the small evangelical church they founded together. The community has a population of about forty people who meet three times a week. "We question everything that represents the traditional church. Both Catholics and the Orthodox are disbelievers as they are confined to Sunday mass," explains Abdullah. "But we are committed to following Christ's word each day and to spread it to those who don't know. It's the life you lead that makes you a Christian." Since they abandoned Islam, the mission of Abdullah and Elmar is to increase the number of believers. "I was born and raised in Dyarbakir. When I was twenty-five years old, I realised that my way of life was wrong and I began to read both the Bible and the Qur'an. God chose me and I converted. Since then I have devoted myself to spread the New Testament," says Elmar. "After I converted, the Kurds started to threaten me, and my family distanced themselves from me. I've come to terms with that. I believe that God has taken away my biological family to give me the whole of humanity." In Antakya different religions coexist: there are 50 Catholics, 2,000 Orthodox, 130 Protestants, Evangelicals and Methodists, the Korean Protestant church and dozens of other churches that preach the New Testament. "Many members of the free churches are Muslim converts. They have the enthusiasm and the focus of novices," says Father Paul, a Capuchin friar from Ephesus. "I respect them because they revitalise the church and they risk a lot doing what they do: in the audience of their sermons there may be government spies or Islamic fundamentalists ready to kill them."

In the Middle East, wars are fought in the name of God and some people are happy to die to become martyrs. A martyr is an indelible mark in history, a totem to worship. For the Egyptian Copts, Mina Daniels is a martyr. On the October 9th 2011, Hosni Mubarak had not been President of Egypt for almost ten months. For weeks there were continuous attacks by Islamic fundamentalists against churches and Christian villages in the south of the country, and the military junta did nothing to stop them. The Copts decided to express their anger with a demonstration in Cairo, in the Maspero district. In a country that had more reasons to complain every day, their parade was more peaceful than others. "There were families with strollers, children with balloons," recalls Yacoub, a close friend of Mina. "It had nothing to do with the fights to oust Mubarak. But the army shot at us and attacked us with tanks. 24 people were killed and among them was Mina". Mina's house is in Ezbet El Nakhal, a suburb of the capital. Two of his sisters live there, while his brother's family live upstairs. His parents stayed in the village. There are photos of Meena everywhere on the walls and they even replace the portraits in his sisters' lockets and rings with his picture. "Once Mina called me from a demonstration organised by the telephone operators to tell me to get there. I asked him what we had to do with the switchboard women and he told me that they were poor like us," continues Yacoub. "Mina could love people and fought for the unity of Christians and Muslims. I envied his energy." There are Christians against the army, Christians against the fundamentalists, even Christians against God. "They taught us to be peaceful, to have faith in God because God gives according to our need," says Yacoub. "The Church wants us harmless, silent. But where was God when those soldiers killed my brother Mina?"

"I suffered four attacks and I lost the same number of bodyguards. My driver's mother was killed for her pension. It is very easy to die in Iraq if you're a Christian." Pascal Warda was minister of social affairs under Ayad Allawi's government, formed in 2003 after the fall of Saddam Hussein. Pascal was the first woman and the first Christian to play an important role in the history of Iraq. Together with her husband and journalist William, Pascal founded the Hammurabi Association for the Rights of oppressed Iraqis. Born after the end of the regime, Hammurabi has become the spearhead of the Chaldean Christians' fight. "Iraq is about to be Islamized and there will be no

more room for Christians. The process began behind the scenes in the Eighties, when Saddam began to portray himself as a devout Muslim. Now they chase us away from our land and deprive us of our language." The Qur'an is used in schools as a grammar text while Aramaic, the ancient language of the Chaldeans, is taught only in one classroom in a specific university faculty. "We want all to be equal before the law and we no longer want to bury our martyrs under a flag that says Allahu Akbar (*God is the greatest, author's note*)" adds William. The couple's home is not far from the glitz and the alienation of the "green zone" where the Government, Parliament and the Western embassies are located. Pascal and William live in a compound protected by high walls and dozens of soldiers sharing prefabricated accommodation with the servants. "We are in the orange zone – a little less armoured than the green one, but still a fortress," jokes Pascal. MPs, former ministers and politicians who need protection all live here. Two drivers are available to Pascal and her family. They drive an armoured car and never go out unarmed. Every time they come back home they kiss the crucifix dangling from the mirror. "When I was still a philosophy student, I visited a Kurdish refugee camp," remembers Pascal. "I saw how Saddam massacred them. I decided to leave school to devote myself to human rights. I became an activist and was forced into exile in France. I continued my battle against Saddam from Europe and I came back when the regime fell. I accepted a post as a minister and I am among those who voted in favour of Saddam's death sentence. I did not think we would have still had so many reasons to fight."

William chimes in: "There is a generation, and there will soon be two, that grew up amongst bombings and checkpoints. This will not get Iraq anywhere. In the chaos following Saddam I was sure it would not be useful to fight the Americans and even less useful to fight among the Iraqis. I was wrong. If we had joined Muqtada al-Sadr (*leader of the Shia militias, author's note*) and we had also killed some Americans, maybe now Christians would be better protected." Iraq and Syria share a present of instability that kills the life plans of the new generations.

When the Syrian revolution began, young people tried to leave the country to avoid being forcibly recruited in the army of the regime or by the rebels. But there are also those who wanted to go to war. "Two years ago, the centre of Damascus was far more

dangerous than it is today," recount three males sitting at the foot of the Orthodox Patriarchate of Bab Touma. "The terrorists were closer and mortar bombs were falling everywhere. It was then that we decided to patrol our neighbourhood". The centre of Damascus had fallen into the hands of the rebels, then it was regained by the army of the regime with the help of the Christian voluntary militias. "We are peaceful people who can and want to live together with the Muslims. But we cannot tolerate that the terrorists sent us away from our cities or treat us as inferior beings. We are not minorities to be sacrificed. For this cause, we will go all the way and win this war," thunders Ahdi, a commander of the army. He founded a volunteer brigade consisting of two Muslims and four Christians in Saydnaya, his native village. "Many kids have decided to help the army. We train them for two weeks in Iran and Russia and then for another 15 days if they want to learn how to use heavy weapons," he explains. Saydnaya rises out of the mountains about 30 kilometres from the capital, where the century-old dust smells sacred and a tenacious fog seems to want to hide the cry for war.

"Saydnaya is second only to Bethlehem. It is the heart of Christianity. There are 37 churches here and this monastery is more than 1500 years old," weeps sister Febronia, mother superior of the convent of Our Lady. "But the world has abandoned us and we have lost the strength to raise our eyes to heaven and ask God to have mercy on us." Close to Saydnaya is Maalula, where they still speak Western Aramaic, the language of Jesus. When Maalula fell into the hands of Jabat al-Nusra (*anti-regime organisation affiliated with al-Qaeda, author's note*), some Christian volunteers joined the soldiers of Bashar al-Asad. It was mid-September 2013 and Ali, a 32-year-old computer technician, was there too. "There were about 60 of us, convinced that it was only right to defend our homes and our history. We fought for three days until the city fell." All the inhabitants fled Maalula and Ali now lives with his aunt in Damascus. Sitting on the couch at home, by candlelight, Ali shows the rifle and his aunt nods. Even if the windows are closed, we can hear the sounds of fighting that accompany the night. The Syrian troops and the Hezbollah allies regained Maalula in May 2014. Many of the historical monuments were damaged or destroyed, and only a small number of Christian families have returned home.

"Will you write about me? Then you must write that I love my President Bashar al-Asad, my people and all Syrians. I have everything I want here, but if this war does not end I'll have to go. Do you think it's right?" Shamo is twenty-five years old, with long blond hair and a contagiously cheery demeanour. He lives with his family in Barabait, or Our Lady's Church, a Christian village which owes its name to a small and ancient church. Barabait is located in the Giazira valley, in North-East Syria and is populated mostly by Kurds and Christians. Here the Kurds first organised resistance against the army of Damascus, then against Isil militias. The Syrian Christians joined the Kurds.

"I know that my parents can walk with their head high because they are proud of me," exclaims Lucien, a 21-year-old. Tattooed from head to toe with Christian symbols, Lucien sits under a carpet depicting the Last Supper. He is a soldier of the Syriac Military Council (SMC), the first Christian army in Syria, founded in December 2013. It includes a few hundred soldiers, only a few of which are older than twenty. Lucien and five of his peers are on guard in the village of Gharduka, the front line in the province of al-Hasaka. The only church in the country is a pile of rubble left by the soldiers of Jabhat al-Nusra Front. There is only a vast uncultivated field between the base and the jihadists.

Orom, a 19-year-old, recalls the battle of Tell Hamis: "We were changing station and I was the guy at the machine gun. I saw an enemy car and I started shooting. I killed four men, but I didn't feel guilty."

Onor gestures with a small Qur'an in his hands. He took it from the first corpse that he ever saw in his life. "It was a sniper that had been shot down. A huge man, dark-skinned and with a very long beard. The booklet protruded from his pocket and I took it instinctively. It was as if I had to have something of his."

Omid has also participated in the battle of Tell Hamis. At thirty-two years of age, he is considered the "big brother" of the boys who followed his training and shared with him the nights at the front and the attacks on enemy positions. Omid lives in Derek, the first village after the border with Iraq, but he is not Syrian. He is a Swiss-Italian from

Locarno and his real name is Johan Cosar. "I went to Syria in January 2013 to make a documentary," says Johan. "I travelled across the whole country up to Derek, where I was given accommodation in the barracks." Johan is the commander of the SMC and one of the military leaders with whom Western allies communicate. "My family is Syriac, from Mardin. Once they emigrated, my father and my uncle continued political activity in Switzerland," explains Johan. "They are the European representatives of the Syriac Union Party, the Syriac party in opposition with Asad's regime". With the outbreak of the revolution in Syria, Johan's father, Sait, joined the first Syriac National Council, the 'opposition government' formed in Istanbul in August 2011. Sait travelled to Syria frequently and exhorts his son to do the same. "But I had a venue in Locarno and led the life that we lead in Europe in our thirties. Work, amusement, a girlfriend," smiles Johan. "I had never been to Syria and I still haven't been to Mardin. I barely remembered Aramaic." After a few months Johan gave in to Sait's pressures and decided to join him in Syria. Prior to his arrival in Kurdistan, he travelled the country at war: he entered it from the western border with Turkey, went through Aleppo, Idlib and Homs before arriving in al-Qamishli, 'capital' of Kurdistan. It is there that he should have met his father, but there was no trace of Sait. After landing at the airport, Sait Cosar was arrested by the regime's police and imprisoned in Damascus. After a long period of silence, the Syrian authorities delivered to his family a sheet that certified his death from a heart attack, "but the time was earlier than the doctor's arrival and the doctor who signed the certificate has confessed that he had never seen my father." More than a year after his death, the fate of Sait Cosar is still shrouded in mystery. But the threads that tie his fate to that of Johan continue to unfold: "When I arrived," says Johan, "the Syrians were organising an army but they were inexperienced. In Switzerland I completed my military service and I was on a mission in Kosovo for five years. I wanted to make myself useful and I have done so by training them."

Johan now knows that he could never forget Omid: "I found out about the history of our community, the genocide suffered by the Turks and the escape to the West. I see them fighting for their place in the world. I help them because it is not right that these people are treated as a minority without rights. Self-determination applies to everyone and if we need to take up arms to obtain it, we are ready."

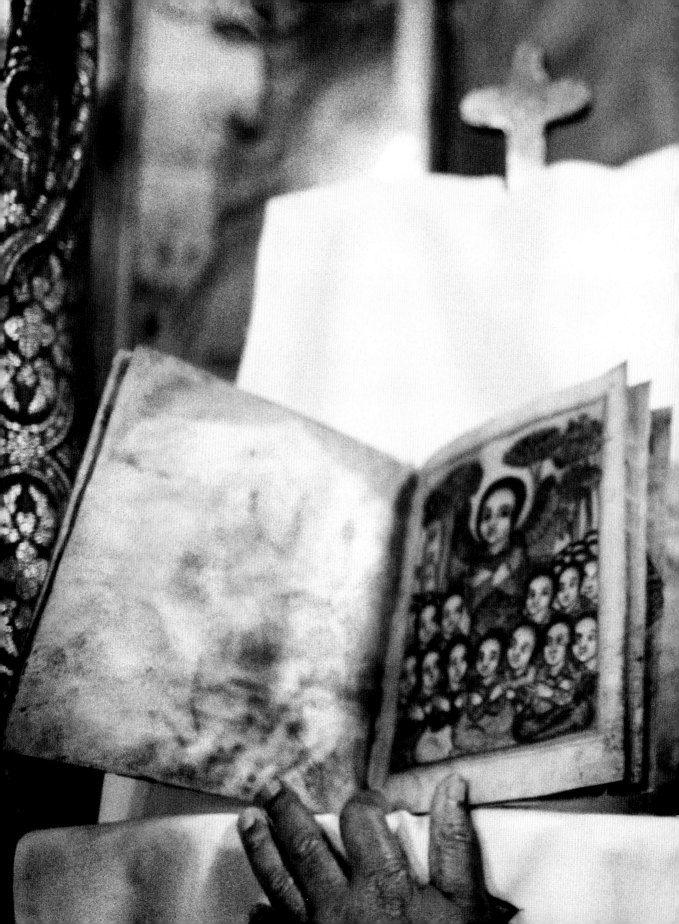

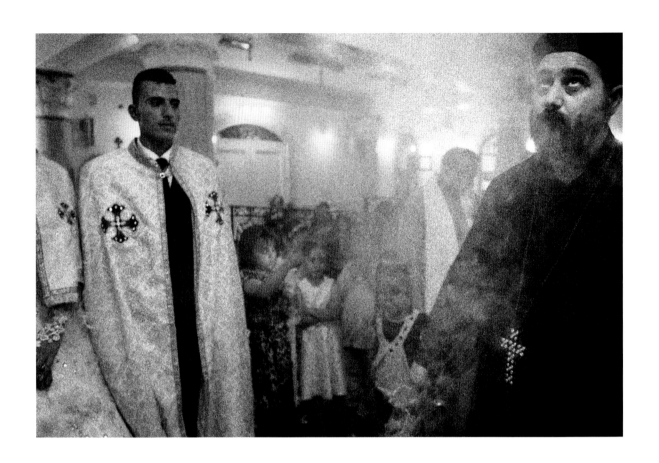

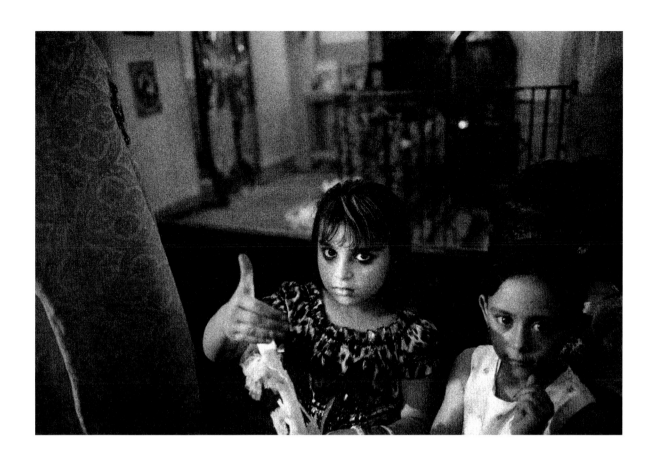

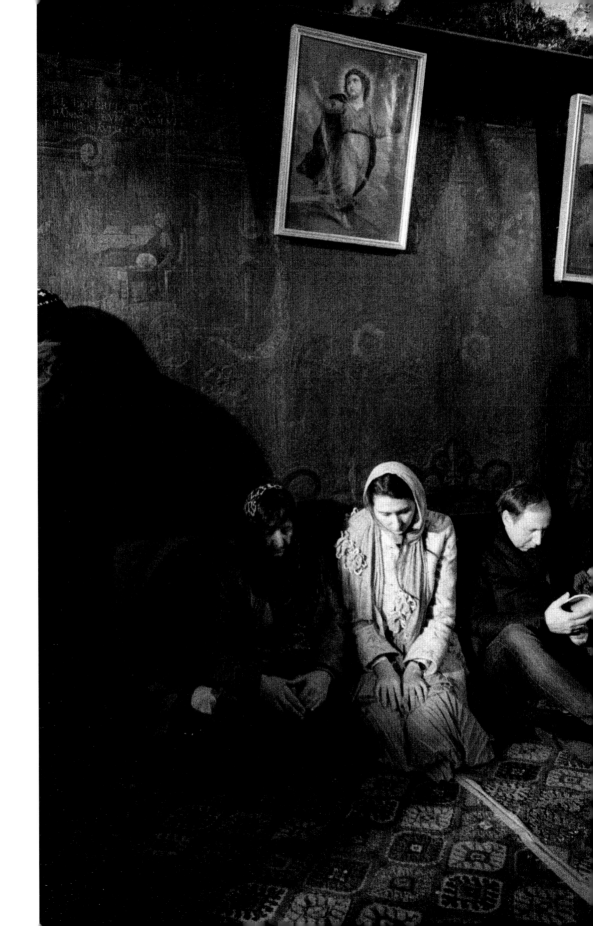

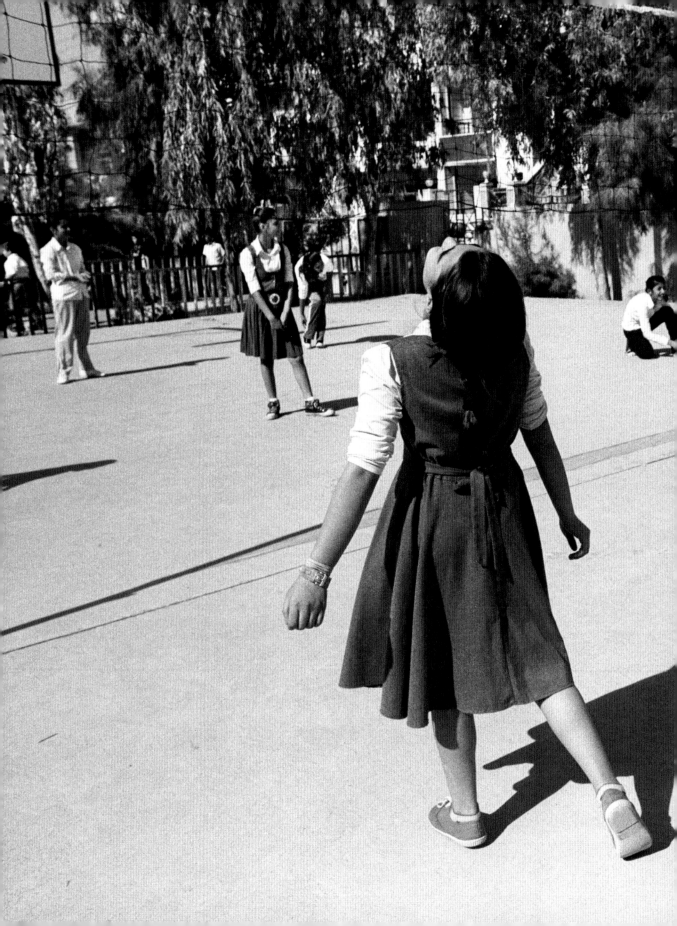

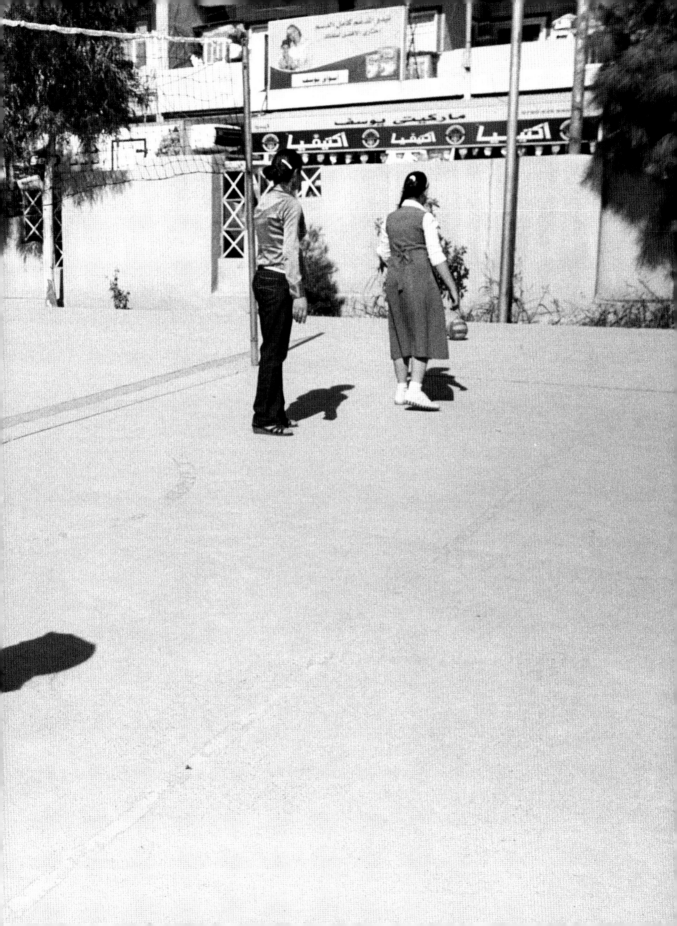

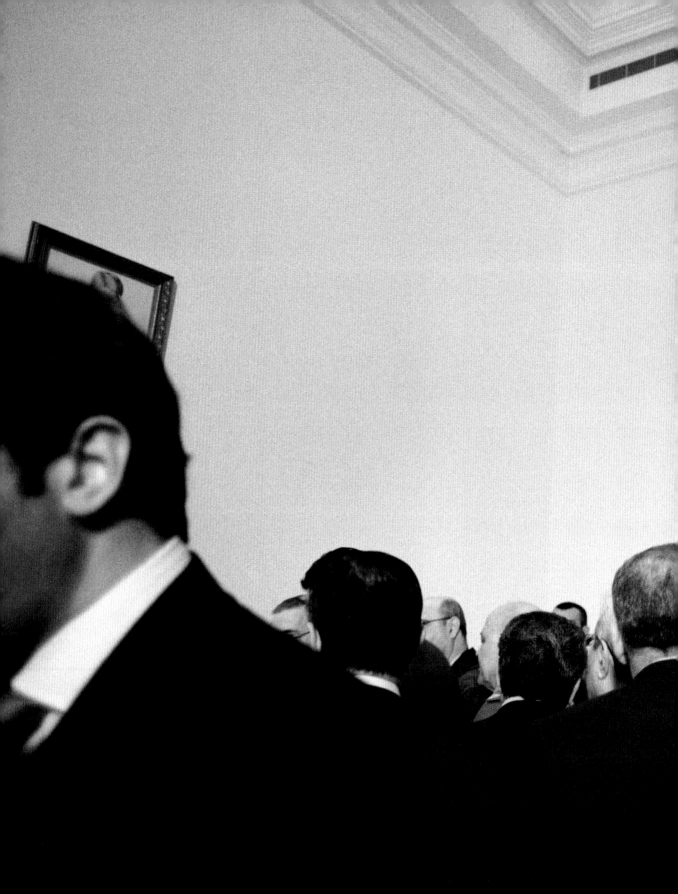

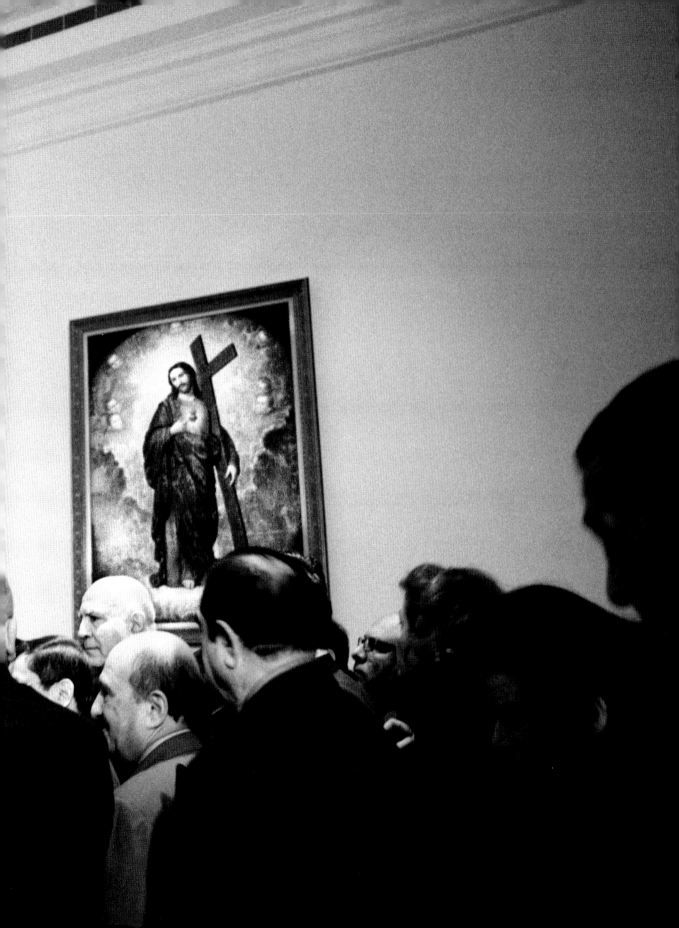

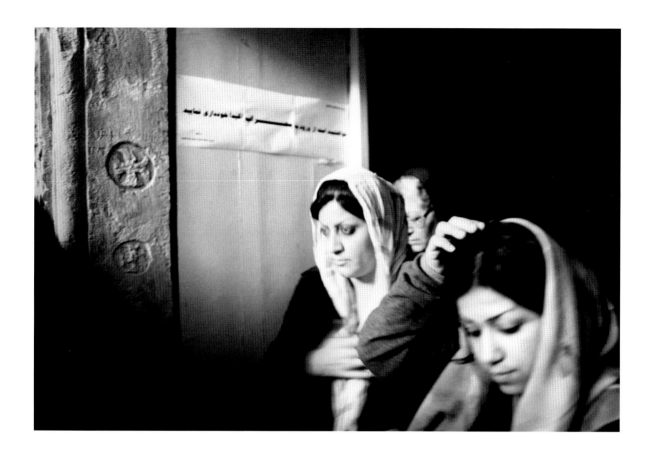

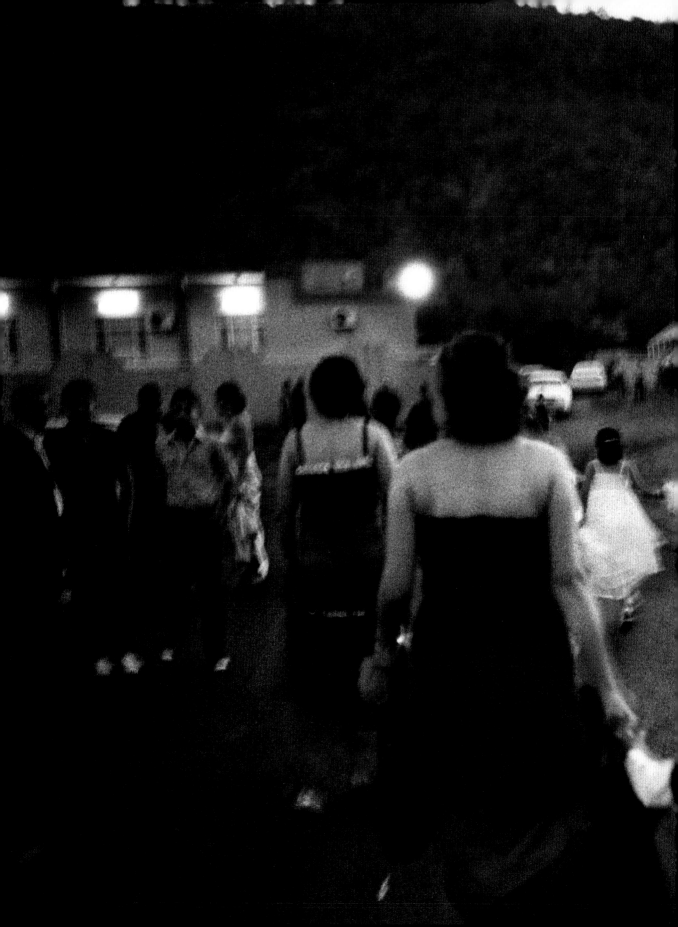

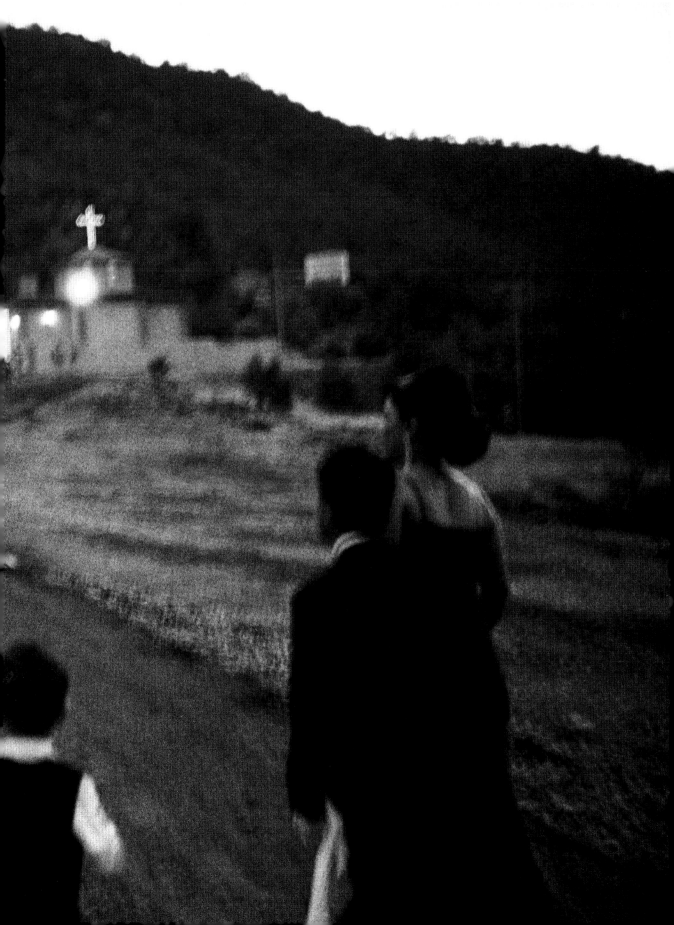

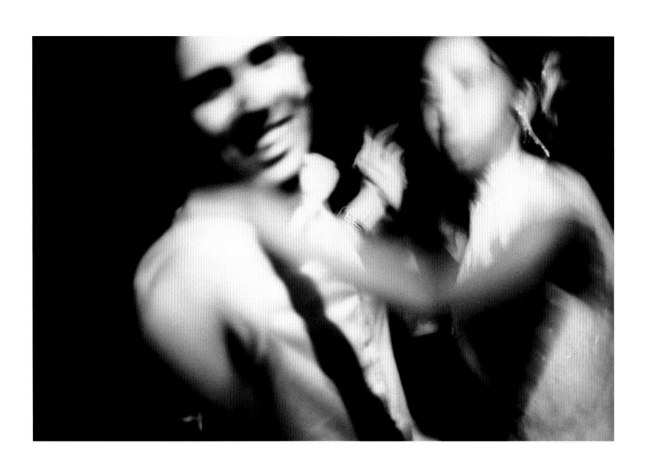

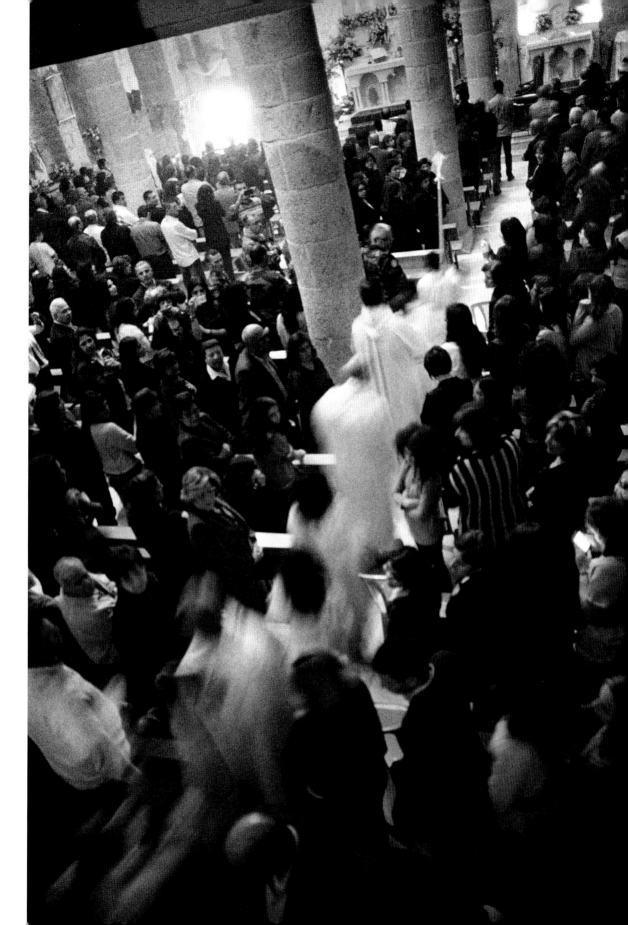

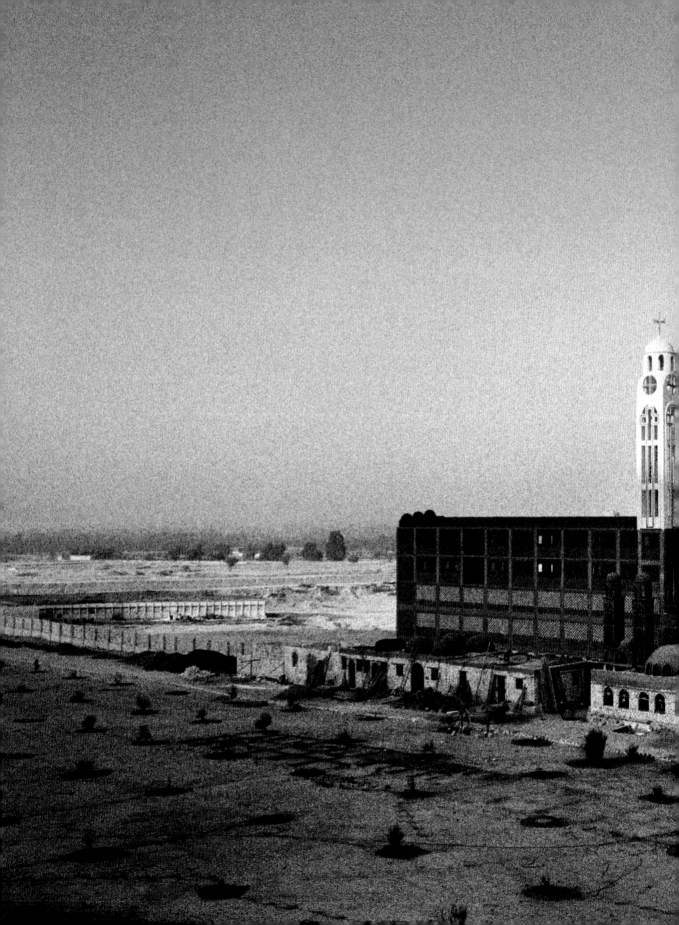

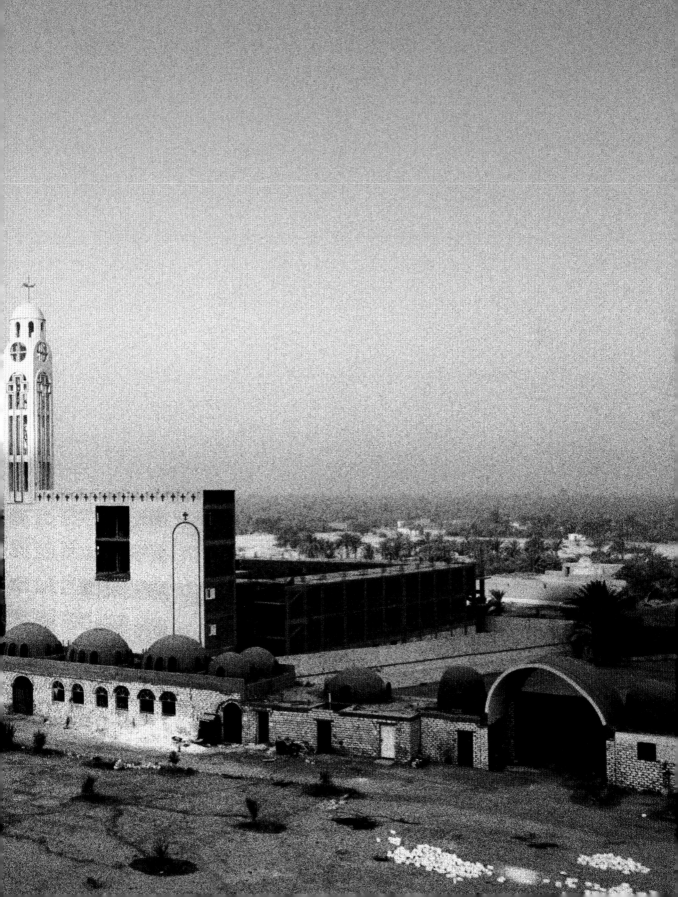

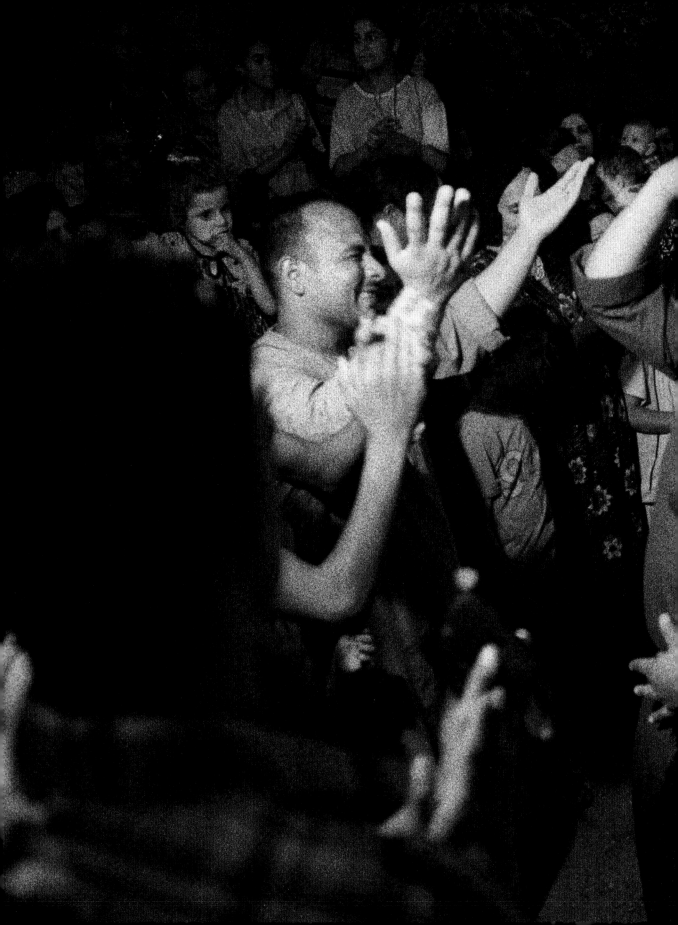

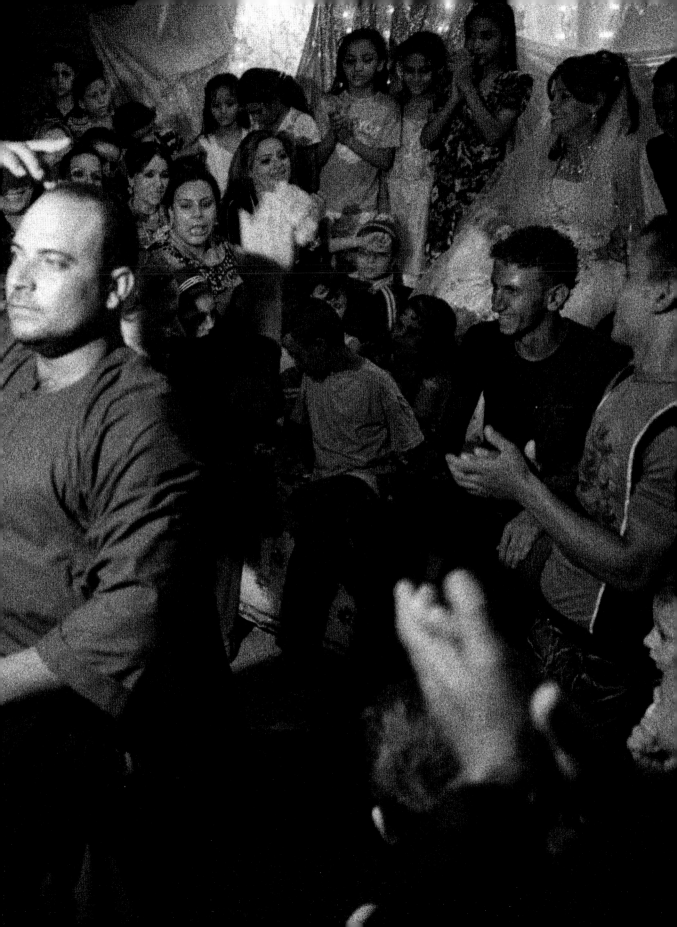

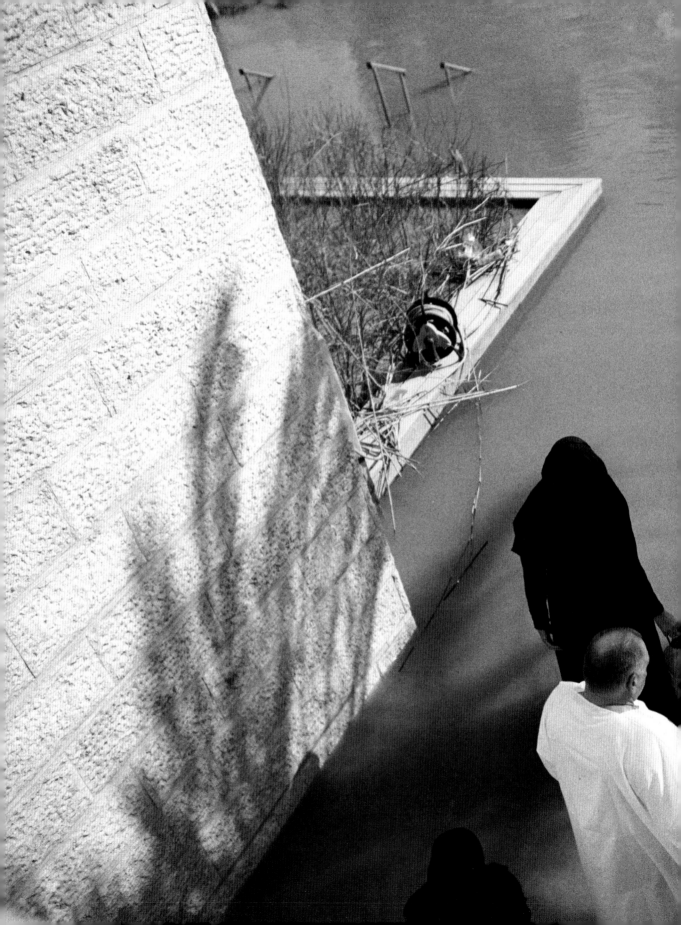

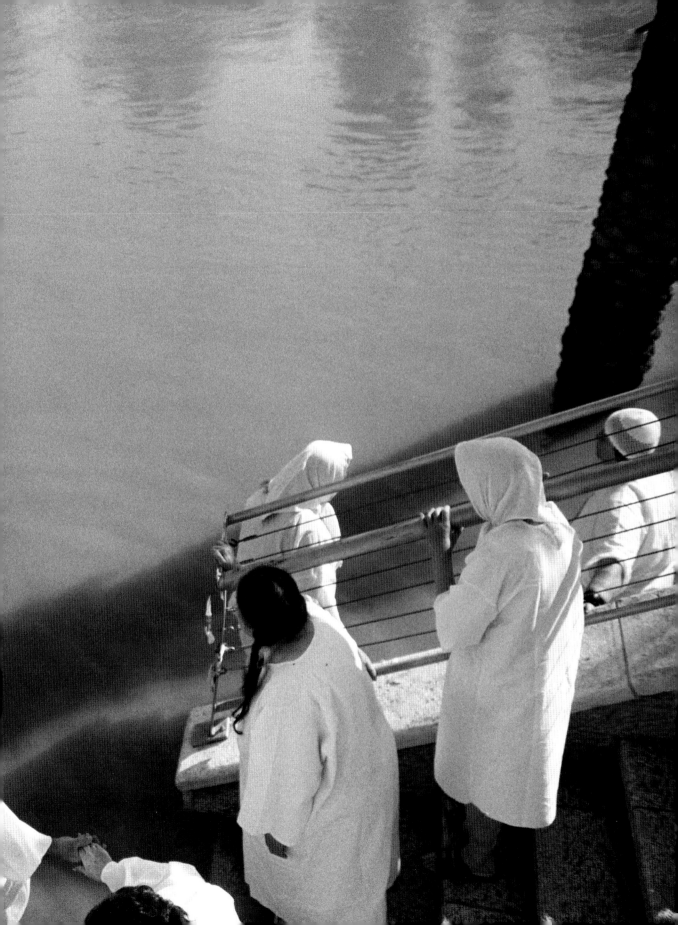

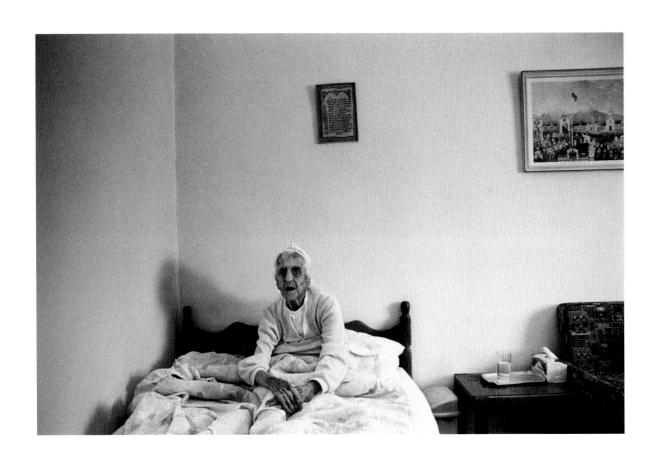

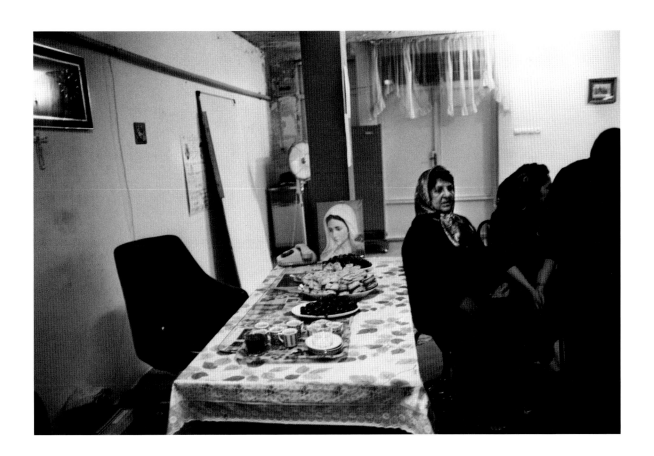

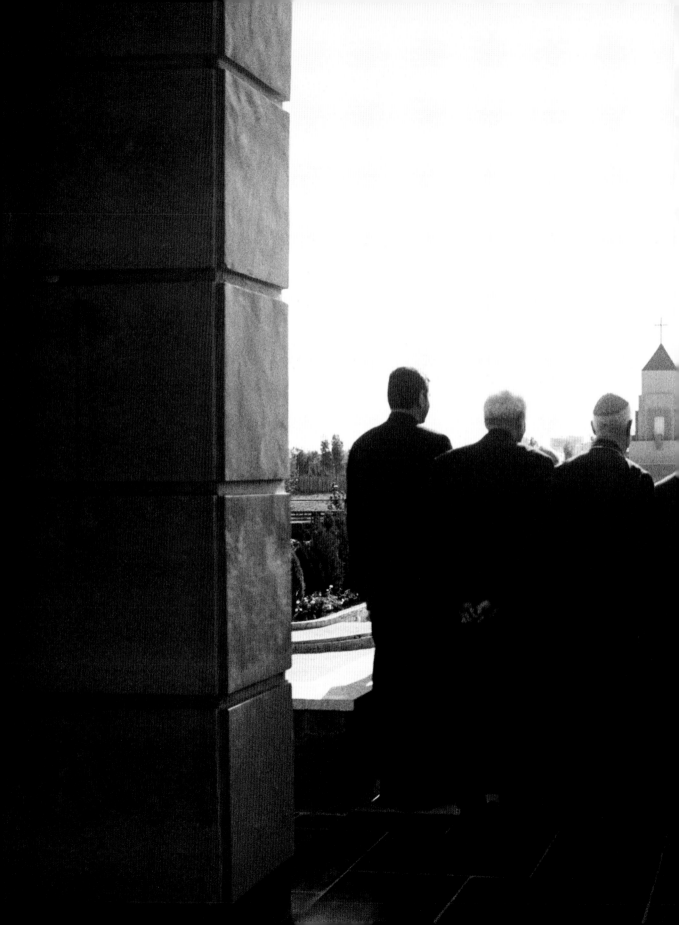

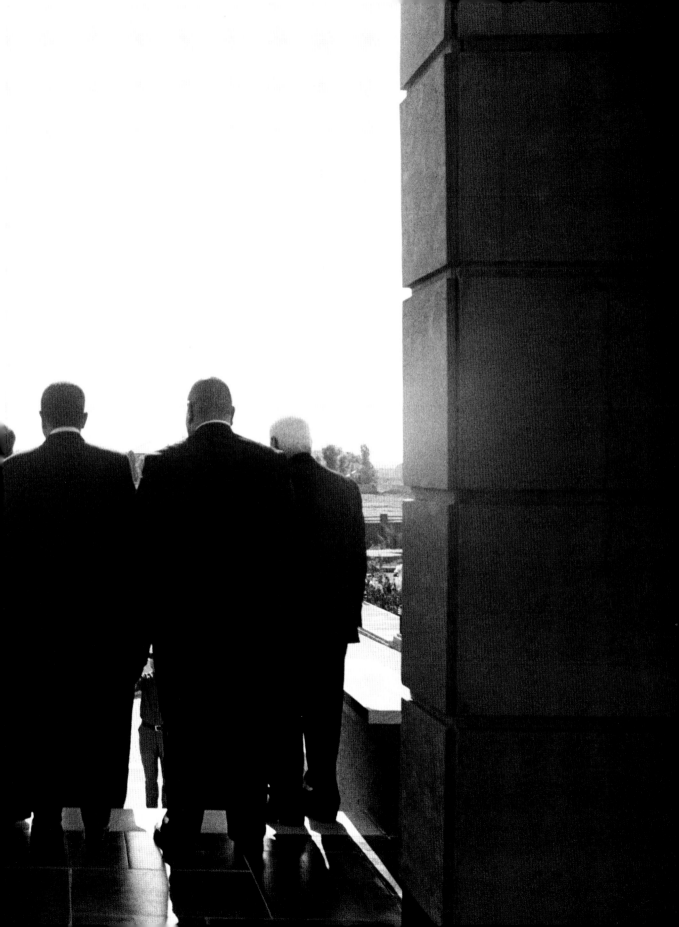

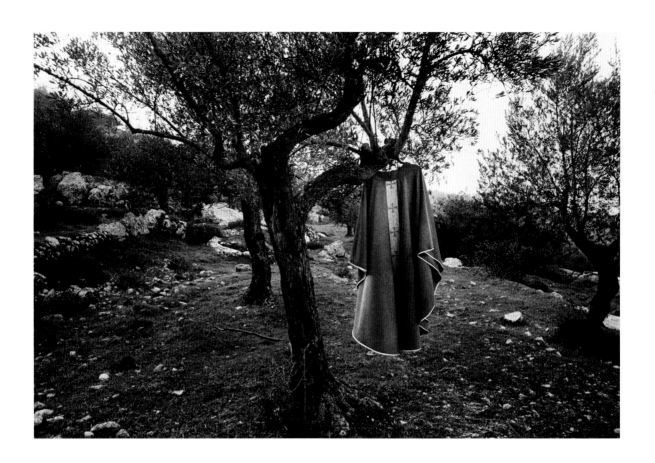

nostalgia

"No, don't help me wash the dishes. Speak to me of love instead. Tell me again about when we first met. You were doing military service and they told you that an Assyrian girl worked in your offices. You went out on the balcony, you saw me downstairs and you threw a pebble near me. Remember? I told you 'come down, I'll open my heart for you'." It is early morning in Tehran. While outside the oppressive smog and city noises rage on, Jan and Clara recall the past in front of yellowed maps and old books on the Assyrian Empire. "Our dynasty disappeared 600 years before Christ came to Earth, but we continue to call ourselves Assyrians. Our art has survived in Iran and Iraq, from Persepolis to Ninive. We no longer have a land, or a nation, but no one will ever erase our identity." Jan and Clara have been married for thirty-five years and have two children in California. "If we were to live in the Western world we would become as secular and indifferent as everybody else. In Iran we are at home and we can defend the last bastions of our identity."

Isfahan is nesf-e jahan, i.e. the corner from where we can peek into the other half of the world. Isfahan is the city where the Persian poet and scientist Omar Khayyam wanted to build his nest to observe the stars. Isfahan, a melting pot of handicrafts and commerce, is the perfect place to lose your soul and entrust it to the wind. Isfahan surprised us: we did find an Armenian quarter, New Julfa. It was built in 1600 and it served as a shelter for the Armenians leaving the lands at the border with Persia and Turkey, on the run from the Ottoman persecution and Shah Abbas the 1st himself. In New Julfa we don't hear the call of the muezzin, cars are not allowed and the sound of ringing bells comes unexpected. New Julfa, so small that it can be walked in fifteen minutes, is home to two churches and the majestic Vank Cathedral. The frescoed walls reflect a yellow gleam that diffuses the city with sunbeams.

Turkey is a colour palette plundered by those who had fun drawing the world. From the Hatai province to the extreme Southeast Anatolia, the road encompasses the names of past and present wars: Şanlıurfa, the city of the prophets, Reyhanli, a door on the war in Syria, Diyarbakır, the chimera of the Kurds. The city of Mardin is a sentinel suspended atop the mountain. The honey-coloured walls reflect the beauty of the past. Its Syriac monasteries retain the spirituality of Eastern Anatolia. Deyrulzafaran, the saffron monastery, is an island in the desert. The monastery appears at the end of a winding path where wild horses chase their own shadow. The light of the dawn paints the contours and the sky turns a shade of blue that helps us track down a small side entrance, open despite the time. We do not hear a noise, everyone is asleep. A corridor comes out onto the courtyard, where we smell flowers and lemons. A flight of stone stairs leads to the roof where some Syrian refugees sleep under a blanket of stars. We find a bed in the living room and we fall asleep. It is morning when the keeper takes his first, discreet steps and the church bells call for mass. After the celebration, friends, strangers and pilgrims gather on the cloister's benches. Bishop Saliba caresses his long grey beard and his smile is the warmest welcome.

"In Mardin there are 3,000 Syriac families left, a century ago they were 130,000. The others have fled, but the umbilical cord with these lands cannot be cut. They wait for the summer to come back. Some nights here, in the house of saffron, we speak five or six languages: Turkish, Kurdish, Arabic, English, German and our Aramaic."

"I am a nostalgic and still call Istanbul 'Constantinople'," begins Konstantinos, a doctor from Thessaloniki. The collapse of the Ottoman Empire left Turkey at the mercy of foreign powers who wanted to divide it among themselves, but the nationalist movement led by Kemal Atatürk opposed them. After defending Turkey, Atatürk and the Kemalists wanted to create the Turks. So, the exchanges of populations begun: Bulgarians and Georgians had to exit through the eastern border of the country, while the Greeks resumed their journey through the Mediterranean. The villages were renamed in the new Turkish language and the coast was depopulated. Today the Greeks are a very small minority, but there is an island in the Sea of Marmara suspended between past and future. "Until the Forties, in Gökçeada there were only approximately fifty

Turkish policemen and civil servants. It was called Imbros, the island of the Greeks, our island. After being driven out, we come here just for holidays," said Konstantinos. The island is made accessible by a ferry that commutes to the mainland daily. Only one bus with a slipshod timetable goes along the road connecting the few villages to the sea. The vegetation grows unrestricted, a lake and some waterfalls are wonders yet hidden to tourism. The road passes through villages whose names have surrendered to the winners. Shinudy has become a mass of ruins called *Dereköy*. The ruins of the old houses are the domain of the many goats that look out of the windows and eat figs from the trees. There are a few isolated homes occupied by some Turkish families, a single bar on the only paved path, and a tiny white church in the background. When Gökçeada was still called Imbros, Billy had not yet been born. Today he's forty years old and he's here on vacation with Elèna, his mother, and Nick, his father. Both Elèna and Nick lived in wealthy families who owned land and animals. When the Christians on the island began to lose security and stability, his parents sent Nick to stay with their relatives in Sydney. Even Elèna was forced to take the same trip. Nick and Elèna's fathers knew each other well and arranged a long-distance marriage. "I had never worked in my life and I found myself speaking a new language, working eighteen hours a day in the restaurant and marrying a man I had never seen before," recalls Elèna. Billy was told this story. He was born and raised in Sydney, works in the restaurant with his mother and is passionate about sports. Every year he spends the summer in Gökçeada and brings with him a diary. The pages he fills are the bond that helps rebuild his cut-off roots.

In the Islamic Republic of Iran, those who renounce their faith in Allah are sentenced to death for apostasy. We meet a man whose name we cannot reveal, who converted from Islam to Christianity. "When I was forty-six, I went to Sweden and I converted. Initially, not even my family knew about it."

The Bible and the rosary are hidden among the pots in the kitchen, the bedroom is intimate enough to pray. "My faith is a source of energy and my god is a guide who knows how to direct me. I do not need anything else. In Iran everything is forbidden. I believe that all religions should be a beacon, not an obstacle. But this regime has taken advantage of Islam. It has ruined it," he continues. "When I was a child I saw the images of

Ashura on TV and I asked myself what was the relationship between all that blood and religion. I then started to read the Bible and to wear a chain with a cross around my neck." The risks are clear to family members but do not generate tensions. "In the past I could go to church more often and more easily. Now there are spies everywhere and I have to be careful not to get myself and the priest into trouble. I never pressured my loved ones to convert, nor have I ever denied Islam and my previous life. My daughters know that if one day they want to leave Iran or change religion they will have all the answers and support they need from me. However, only outside these boundaries."

"I would like to get married in church. For the music, I think. And for the atmosphere," says one of the daughters, smiling.

As we move on, the beeping of car horns is replaced by the noise of tractors and the grey and dense city air dissolves into a fresh morning breeze. In local homes, outdoor breakfasts based on bread, cheese and jam are being prepared. Pataver comes alive for August 15th, the feast of the Assumption. This small village in the north-western part of Iran is the last refuge for the Assyrian Christians. George's jeep jumps from one hole to another on a path in the woods, until we come to what was once a stable and is now a church. Well hidden by the trees, a small door forces us to lower our heads to get in. "I went to live in the United States and I had stubbornly decided I wanted to grow old in Italy or in France. I'm renovating my family home in Pataver instead, where the birds wake me up in the morning and in the evening I can climb on the roof to watch the stars." In the past there were fifty Assyrian families, today we can count them on the fingers of two hands.

"We have our schools and our priests. We can teach our language and religion. But here only the elderly are left," says Olga, who lives in Paris and comes to Pataver when the West goes on holidays. "Our daughters should not wear a veil, nor should they be afraid of being kidnapped or forced into marriage. But what will they do when they have to go to college or work? Here there are no possibilities, therefore they will decide to leave and even this corner of paradise will become empty".

In Pataver we breathe the gripping nostalgia of the Assyrians, or members of the Eastern church, whose name already embeds the melancholy of remoteness.

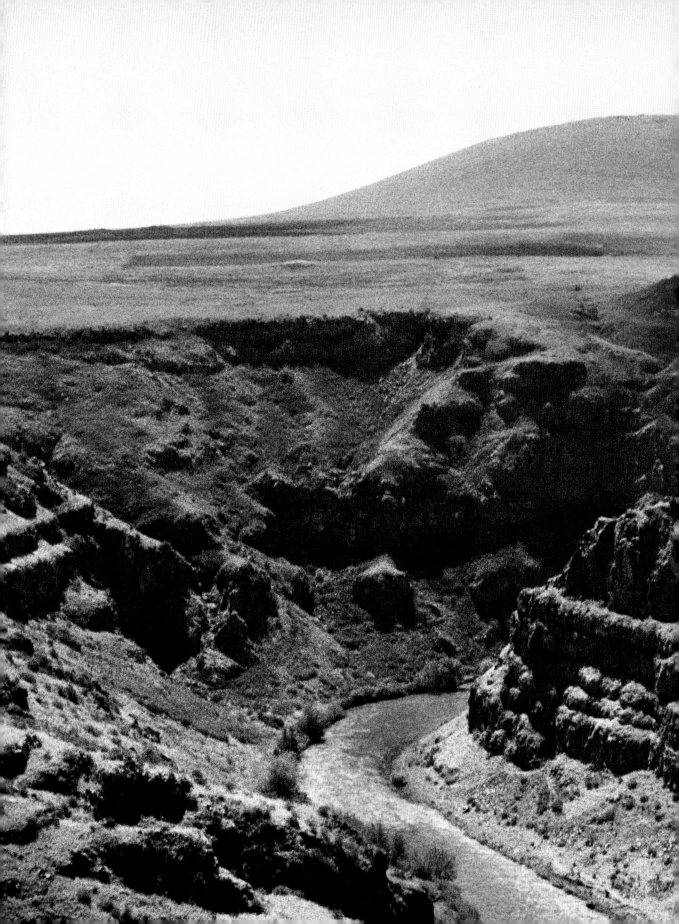

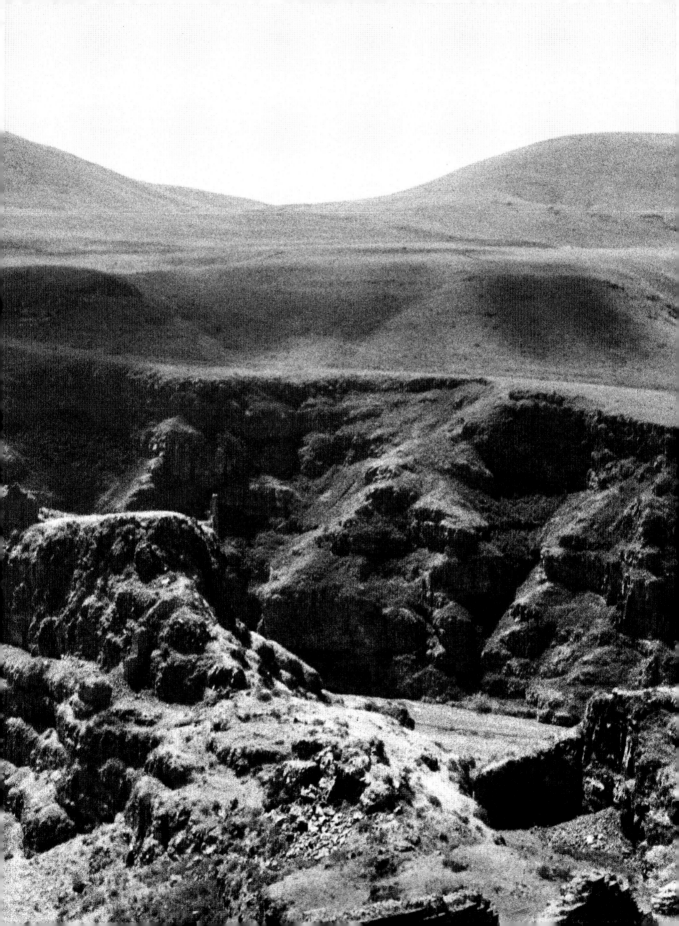

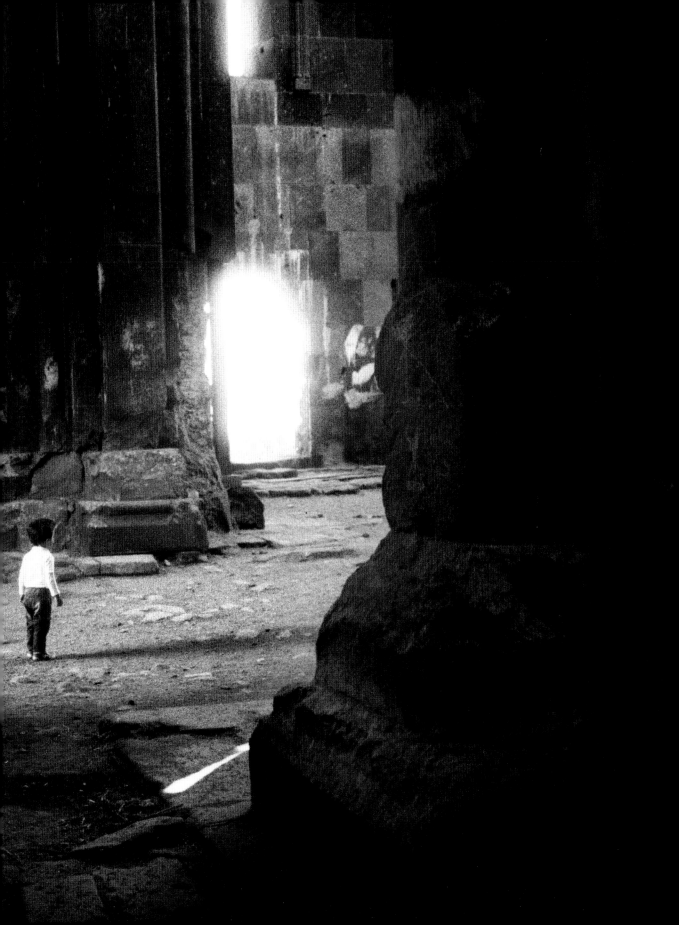

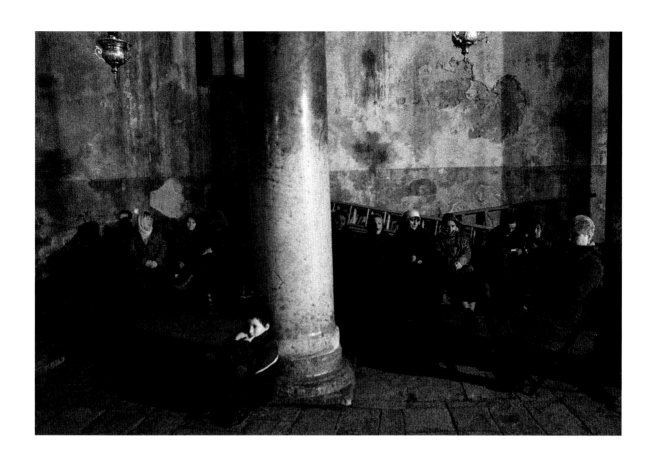

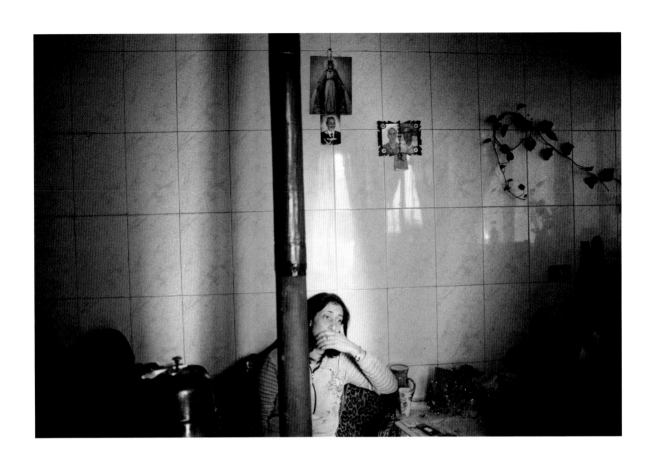

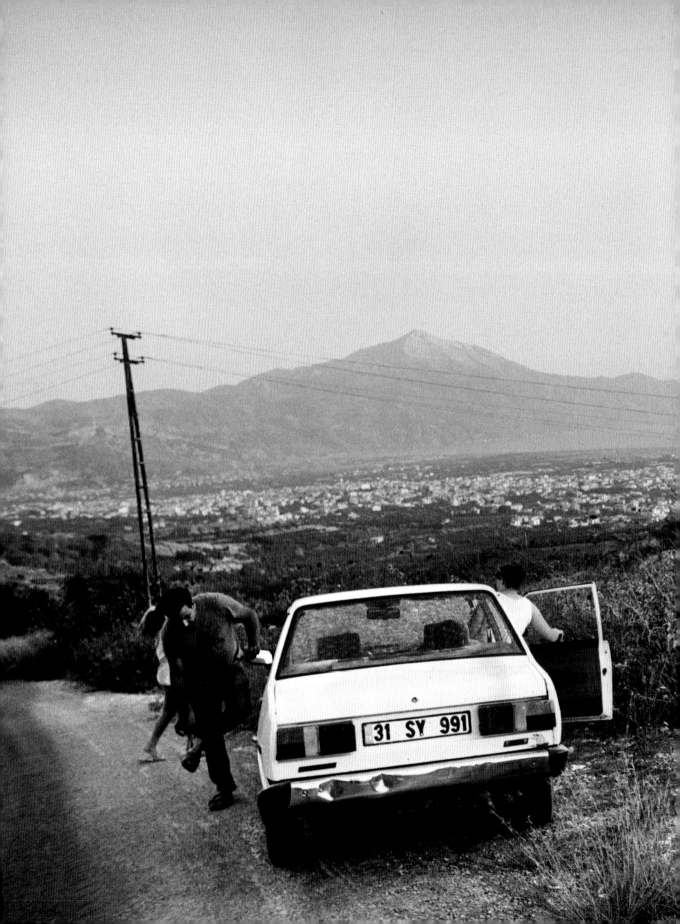

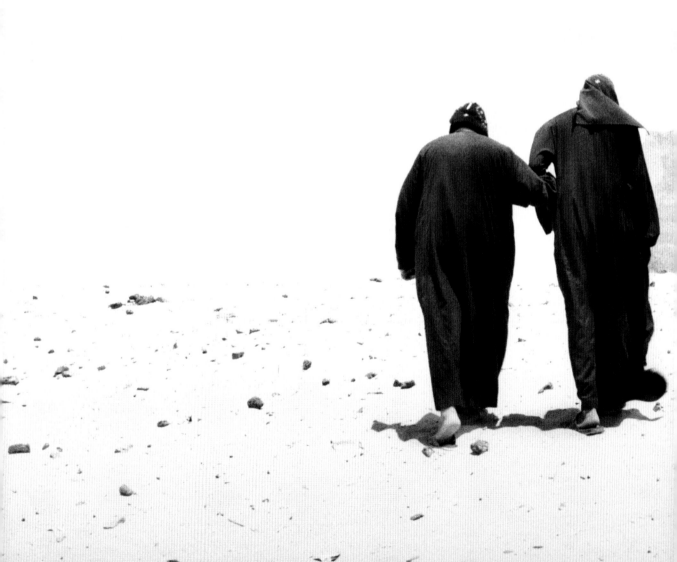

Deir Abu Hennis, Egypt. All the inhabitants of the village are Christian Copts. The Nile river separates them from the rest of Egypt.
July 2012.

Sere Kanye, Rojava, Syrian Kurdistan. Most of the people of the Northeastern part of Syria are Kurds. Together with the Christian Syriacs and the few Arabs living there, Rojava declared its autonomy from Damascus.
January 2014.

Salmas, Iran. There are two cemeteries in the village. The mortal remains of the first Christian inhabitants are kept in one of them. Many graves have been desecrated by thieves looking for gold.
August 2011.

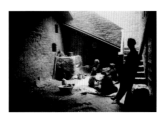

Il Cairo, Egypt. A zabbalin family in their home at the foot of the Mokattam mountain. All the zabbalins are Christians working as dustmen, living among the rubbish of "Garbage City".
July 2012.

Zgharta, Lebanon. Zgharta is a city in the north of Lebanon where many important Christian politicians were born.
February 2012.

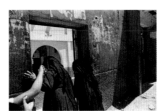

Deir Abu Hennis, Egypt. Two Copt women at the church's entrance.
July 2012.

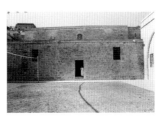

Mardin, Turkey. The 40 Martyrs church and its garden, open till midnight, is the central meeting point of the Christian community. Muslims are not welcome.
July 2013.

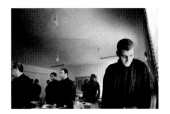

Kfifan, Lebanon. Every year, the monastery of Saint Cyprian and Justina receives hundreds of young seminarists from all over the world.
September 2011.

Jerusalem, Mount of Olives. The Israeli government is planning to build a new section of the separation wall, which would separate the Arab districts of the city from the West Bank.
December 2012.

Derek, Rojava, Syrian Kurdistan. A Muslim woman is the guardian of the only church in a small village near Derek, where there is just one Christian family.
January 2014.

Salmas, Iran. Salmas is an ancient Assyrian village near the border between Iran and Turkey. The few Christians left there live peacefully together with the Kurds.
August 2011.

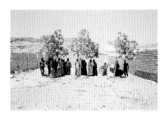

Deir Abu Hennis, Egypt. A funeral in the little village in Upper Egypt. Many of its inhabitants never left the village.
July 2012.

Saint Thaddeus monastery, Iran. The yearly Armenian pilgrimage.
July 2011.

Qaraqosh, Iraq. The launch for Mar Shimun holiday.
November 2012.

Saydnaya, Syria. A nun inside Our Lady monastery, the second most holy place for Eastern Christianity. Bethlehem is the holiest. Many Christian holy places close to Damascus have been destroyed by the jihadists.
January 2014.

Bara Beyt, Rojava, Syrian Kurdistan. A Christian family that lives close to Chiesa Madonna, one of Syria's most ancient churches. The woman is making bread.
January 2014.

Bethlehem, West Bank. The Nativity cave is located under the main altar of the church. At Christmas, holy masses are celebrated amid many foreign believers and tourists.
December 2012.

Derek, Rojava, Syrian Kurdistan. This part of the country is embargoed by Turkey. People are suffering from lack of food and water.
January 2014.

Tyre, Lebanon. Easter celebration in the Maronite church.
April 2012.

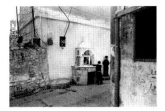

Tyre, Lebanon. Men near a shrine. Tyre is a city divided between Christians and Muslim Shiites.
April 2012.

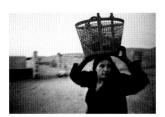

Deir Abu Hennis, Egypt. A woman going to the cemetery to leave food on her husband's grave.
July 2012.

Deir Abu Hennis, Egypt. After fasting, the inhabitants of the village are allowed to eat meat and milk derivatives again. At sunrise, a butcher kills one of his cows and sells the meat on the streets.
July 2012.

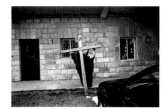

Near Ajloun, Jordan. The cross used in the Easter procession.
March 2013.

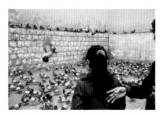

Damascus, Syria. The Umayyad Mosque is situated in the centre of the old city. It is one of the most ancient and holy sites of Islam. The ongoing fighting in Syria has barely touched it.
January 2014.

Baghdad, Iraq. Armenians come to the church of Saint Mary to make a wish. The story goes that a girl came here with a sort of woollen thread which believers bring with them: if it is cut, their wish will come true.
November 2012.

Holy Sepulchre, Jerusalem. The church is divided among the different Christian creeds.
January 2014.

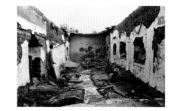

Gharduka, Rojava, Syrian Kurdistan. Gharduka is on the frontline between the Kurds and Isil. The village is empty and its only church has been destroyed by the jihadists, who bombed it after using it as a trench.
January 2014.

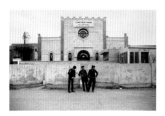

Baghdad, Iraq. Saint Mary church is on Palestine Street, a northern suburb of Baghdad. The church was stricken by a suicide attack in 2010 – two people died. Since then, the church is constantly under guard.
November 2012.

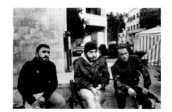

Damascus, Bab Touma. Damascus citizens have created some volunteer militias, paid by the government, to patrol the city. The picture shows three Christian men in front of the Orthodox Patriarchate.
January 2014.

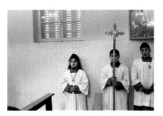

Near Ajloun, Jordan. Altar boys and girls serving the Easter mass.
March 2013.

Trabzon, Turkey. Where there was once a church, there is now a car park.
August 2013.

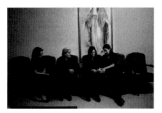

Zgharta, Lebanon. A funeral. Women and men are separated.
February 2012.

Holy Sepulchre, Jerusalem. Every Friday, Capuchin monks stage the Via Crucis in the streets of the city.
January 2013.

Smakieh, Jordan. A statue of the Virgin Mary in the cemetery of this little village in the south of the country. Only two Christian families live there.
April 2013.

Jerusalem. The guardian of an Ethiopian church showing an ancient copy of the Bible. The Christian community includes Catholics and Orthodox, Egyptian and Ethiopian Copts between Damascus gate and Jaffa gate.
December 2012.

Saint Thaddeus monastery, Iran. The annual pilgrimage is the occasion to celebrate weddings and baptisms. St. Thaddeus was one of the first martyrs of Christianity. The Black Church is dedicated to his memory.
July 2011.

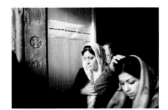

Saint Thaddeus Monastery, Iran. Iranian women are obliged to wear a veil covering their hair, and a manta-like fabric over their trousers. During the pilgrimage, Christians do not have to comply with the regime's laws, though they are monitored by policemen.
July 2011.

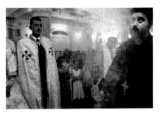

Deir Abu Hennis, Egypt. An Orthodox wedding. The Catholic community of the village is a minority, but the relationships between the two denominations are good. During festivities, representatives of the denominations pay tribute to each other.
July 2012.

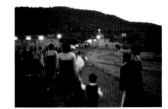

Karia Rounta, Iraqi Kurdistan. Wedding celebration.
October 2012.

Deir Abu Hennis, Egypt. Little girls in church during a wedding. Due to the Orthodox rules, women cannot cross the altar line when they are 'dirty' because of their menstrual cycle.
July 2012.

Tehran, Iran. The celebration of an Armenian marriage.
August 2011.

Bethlehem, West Bank. The Catholic Christmas festivity inside the Nativity church. The space inside the church where Jesus was born is assigned to different Christian creeds. Christmas is celebrated four times in the Holy Land.
December 2012.

Saint Thaddeus Monastery, Iran. The Black Church is open all night during the pilgrimage.
July 2011.

Erbil, Iraqi Kurdistan. The Kurdish autonomous region respects the co-existence between ethnicities and faiths. In this school, Arabs and Kurds, Christians and Muslims learn Arab, Kurdish and Syriac languages.
October 2012.

Ain Ebel, Lebanon. The Easter mass. The village is close to the border with Israel and many U.N. soldiers attend the mass.
April 2012.

Beirut, Lebanon. Celebration of Saint Maroun, the patron of the Maronites, in the Cathedral of Saint George.
March 2012.

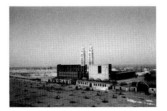

Deir Abu Hennis, Egypt. Construction of a new monastery. Christians have been targeted in Egypt following the fall of Morsi on July 2013 as the Islamic extremists blamed them for supporting the protests that led to the change in government.
July 2012.

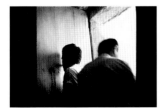

Saint Thaddeus Monastery. Every year, the Armenian community stages a three-day pilgrimage to the Monastery at the border between Iran and Turkey. It dates from 68 AD, and was one of the first Christian churches.
July 2011.

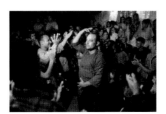

Deir Abu Hennis, Egypt. Dancing in front of the bride's house.
August 2011.

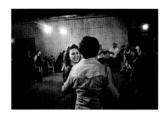

Pataver, Iran. Festivity for Saint Mary. The village gathers in the church's garden for dancing, eating and drinking alcohol. Outside the wall, such behaviours are not allowed, so policemen patrol to make sure none of this happens on the outside.
August 2011.

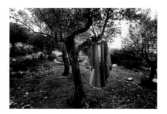

Beit Jala, West Bank. The Israeli government plans to build another part of the separation wall on the land where Christians own olive fields. Christians of Beit Jala celebrate a mass every Friday, in an attempt to prevent the project.
January 2013.

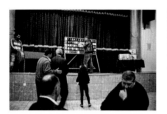

Zarqa, Jordan. Abuna Elie is the priest of the Latin parish of the city. Once a year he organises a bingo event to collect funds for the parish activity.
April 2013.

Close to Ani, Turkey. The closed border between Armenia and Turkey.
August 2013.

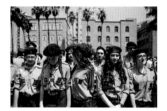

Beirut, Lebanon. Armenian female scouts during the demonstration against Turkey for the anniversary of the 1915 Armenian Genocide.
April 2012.

Ani, Turkey. Ani is the ancient capital of the Armenian empire, situated at the closed border between Armenia and Turkey. Nowadays, Ani consists of a pile of church ruins, homes and the Cathedral.
August 2013.

Yardenit, West Bank. The Jordan river counts various Baptismal sites for both local and foreign people. The Catholic Church, though, recognises only the Qasr el Yahud site, between Israel and Jordan.
January 2013.

Sulaymaniyha, Iraqi Kurdistan. A tombstone in the Mariyam al-Adhra monastery, the new location for the al-Khalil community, which has been turned away from Syrian Deir Mar Musa.
November 2012.

Anjar, Lebanon. Anjar is an Armenian village close to the border with Syria. This woman is one of the last remaining survivors of the 1915 Armenian Genocide.
April 2013.

Bethlehem, West Bank. Orthodox pilgrims in the Nativity church before Christmas mass.
December 2012.

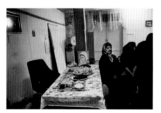

Ahwaz, Iran. Celebrations of a funeral. In this southern city at the border with Iraq there are few Assyrian families working on oil fields.
August 2011.

Qaraqosh, Iraq. Celebration of the martyrdom of Mar Shimun, one of the first Christian martyrs, killed with her seven children because she refused to convert to Islam.
November 2012.

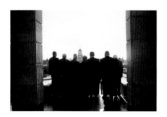

Erbil, Iraqi Kurdistan. A gathering of bishops from all the Iraqi cities to discuss the dangerous situation in the country.
October 2012.

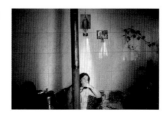

Jaramana, Syria. This woman is a displaced person. She was forced to leave her home city and she is living with her sister and mother in an area measuring 15 square metres.
January 2014.

Pataver, Iran. Inside the house of a Christian family.
August 2011.

Saint Veni monastery, Egypt. The monks of this monastery near Mallawi, Upper Egypt, have been assaulted many times by fundamentalist Salafis from nearby villages.
July 2012.

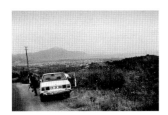

Landscape surrounding Vakıflı Köyü, Turkey. The coastal region of Hatay was part of Syrian territory till the Second World War.
July 2013.

Around Kars, Turkey. Almost all of eastern Turkey was inhabited by Armenians during the Ottoman Empire. Nowadays there are a few Turkish villages, where sheep farming is the main activity.
August 2013.

Basra, Iraq. An amusement park in the southernmost city of the country. Basra citizens are mostly Shiite Muslims, since Christians left as a result of post-Saddam's civil war.
November 2012.

Marmara Sea, Turkey. Many islands of the Marmara Sea were inhabited by Greeks. President Atatürk ordered a population exchange between Turks and foreigners and the Greeks left their lands.
August 2013.

Vakıflı Köyü, Turkey. This is the last Armenian village of the Musa Dagh, known as 'Moses mountain'. The people of the eight surrounding villages were able to outlive the genocide perpetrated by the Ottomans. Almost 180 Armenians still live here.
July 2013.

Tabriz, Iran. The guardian of a church, closed for restoration for the last three years . But the work is at a standstill.
July 2011.

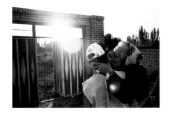

Pataver, Iran. Olga is a Christian Assyrian who emigrated to Paris. Every summer she goes back to her homeland. Less and less people live in the Christian villages of Northwestern Iran.
August 2011.

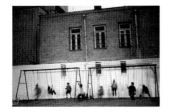

Tabriz, Iran. The life of the Armenian community revolves around the parish, which has a church, a kindergarten and a garden. A high wall surrounds it.
July 2011.

ACKNOWLEDGEMENTS

First of all, we would like to thank all of the people we met during our journey and especially Leila and Volkan for providing such solid support. Without you, *Rifugio* simply would not exist.

Thanks also to our friends and colleagues for your contacts, suggestions and encouragement. In particular, we owe a debt of gratitude to Lorenzo Trombetta and Alberto Zanconato, Francesca Paci, Michele Giorgio, the Rojava Free Media Center, Emergency, and Un Ponte Per and Icssi.

We are also grateful for the invaluable advice provided by Raphaelle Brui Boccaccio, Michael Ackerman, Adam Cohen, Machiel Botman and Magda Iacopini, Chiara Capodici, Mattia Visintini, Rodolfo Bisatti and Laura Pellicciari. In addition, we would also like to thank Davide Di Gianni for his helpfulness and expertise. Many thanks to Antonella Marrone and Fondazione Crocevia for the text editing.

Our special thoughts go out to Raethia Corsini and Guido Levi and we are also thankful to Annalisa D'Angelo for believing in our work from the very start.

We are very grateful to Maarten and Maria Louise Schilt for their trust.

Finally, we would like to express our debt of gratitude to our families, who, although far away, were always in our thoughts and supported us throughout this project.

ISBN 978 90 5330 843 1
© 2015 Linda Dorigo (photography)
www.lindadorigo.com
© 2015 Andrea Milluzzi (text)
© 2015 Schilt Publishing, Amsterdam
www.schiltpublishing.com

Edit
Linda Dorigo, Annalisa D'Angelo and Victor Levie

Book design
MV LevievanderMeer, Amsterdam
www.levievandermeer.nl

Translation from Italian to English
Valentina Scaramella, London
www.valentinascaramella.com

Text correction
Kumar Jamdagni, Language Matters, Zwolle
www.language-matters.nl

Print & Logistics Management
Komeso GmbH, Stuttgart
www.komeso.com

Printing
Bechtel Druck GmbH & Co, KG, Ebersbach (D)
www.bechtel-druck.de

Distribution in North America
Ingram Publisher Services
One Ingram Blvd.
LaVergne, TN 37086
IPS: 866-765-0179
E-mail: customer.service@ingrampublisherservices.com

Distribution in the Netherlands and Flanders
Centraal Boekhuis, Culemborg

Distribution in all other countries
Thames & Hudson Ltd
181a High Holborn
London WC1V 7QX
Phone: +44 (0)20 7845 5000
Fax: +44 (0)20 7845 5055
E-mail: sales@thameshudson.co.uk

Schilt Publishing books, special editions and prints are available online via www.schiltpublishing.com
Enquiries via sales@schiltpublishing.com